through the rings

~A PHOTO JOURNEY~

By: Ruben Sanchez

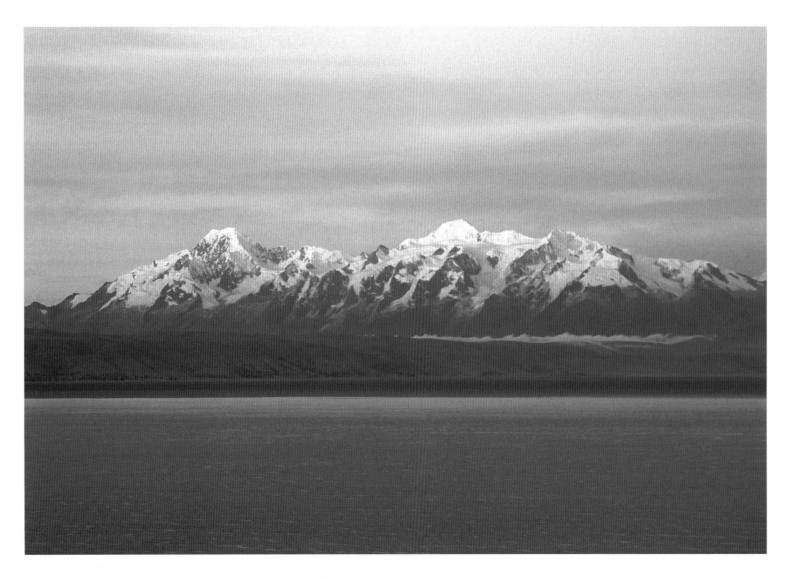

First printed November 1999, Through the Rings Publications
ISBN-0-9676918-0-X
Printed in China

Dedicated to my family who I love dearly,
to all the athletes in this book, and all the friends I've made in my lifetime so far.

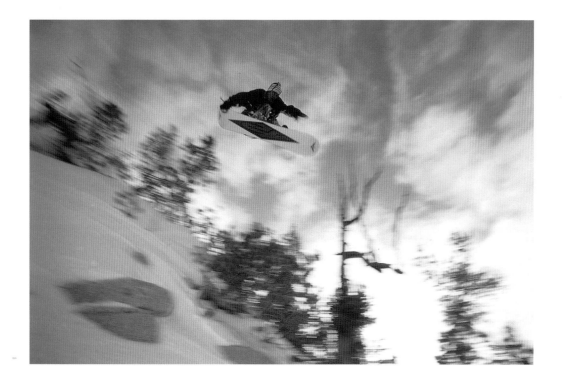

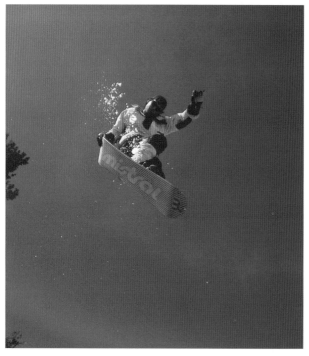

intro

Time passes, leaving behind increments of experience and memory. The recollection of moments gone are crucial to our understanding of who we are and who we will one day become. Through the compilation of these segregated passages, the definition of an era is born. Here in the last decade of the millennium, society itself seems obsessed with our propensity to progress.

While the blur of this progression often leaves the casual observer reeling in mystery, there are those who were sent here to document and help define this time and the people taking part in the insanity. The ability to arrest time and hold it captive for humanity to observe is the duty of the photographer. The subject moves through time in it's own space, making what the photographer captures, unrepeatable. Through the mind's eyes, a millisecond of action is beheld for others to view forever.

As the eighties moved into the nineties, groups of people began coming together to stimulate and take part in the progression at hand. These groups were often conglomerations of people from other places and different histories. By circumstance, kinships were founded that provided support and encouragement to live life at the next level. These relationships have created an energy that ignites the spirit deep within and pushes experience forward.

One such group was brought together in late 1989, in Incline Village, Nv. Two separate crews of people were brought together by the common love of snowboarding. Rob Dafoe and Ruben Sanchez from Goleta and myself from Palmdale. We had a mutual friend, Merrill, who united us and the Juanita clan formed, putting the future in motion. At that time, there were many people moving to Tahoe, some to chase the dream of professional snowboarding, some to just live and ride everyday.

Unbeknownst to all of us, a birth of an era was created during these times. Pure circumstance put us in the position to meet and befriend some of that times heaviest hitters in the snowboarding world. The 'Totally Board' series was created in that same year and 'The Western Front' was also just released, both defining moments in the world of our sport. Everything was casual and very close nit, free of the vibe of competition and ego. That would soon change forever.

That year was pitiful in terms of snow, but none of us even noticed. Everyday was an entirely new and different experience. Each of us feeding off the absolute stoke. Then, after virtually no snow that whole season, the 'miracle' occurred. It snowed upwards of twenty feet in one week, leaving us completely dumbfounded. All of the old timers had no idea of what they were in for the following weeks. Living in Incline had removed us from the rest of the 'scene', but we worked night and day on creating our own deal. With too much snow for even the authorities to manage, the town was ours. Everything became the focus of our attention. The penchant for riding our boards mixed with some of natures finest herbs and plantlife produced some of the most creative and exhilarating times of the year. A form of alchemy had occurred in all of us. We were all so poor but so happy that this heavy resilience was created. Nothing mattered as long as we could ride the next day.

We were all discovering who we were and the bond that was established helped keep us all in check. Merrill, being the oldest was deemed 'dad', a role that he had to live up to more than a few times that year. Freedom mixed with a crazy sense of adventure made our house the good times center. We even had a trampoline in the living room. (When we moved out I always thought that the landlady must have tripped out on the foot prints on the ceiling, thirty feet above the living room floor).

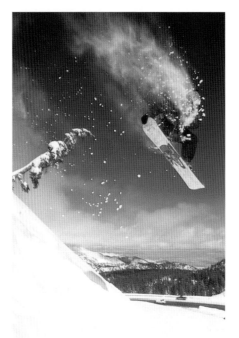

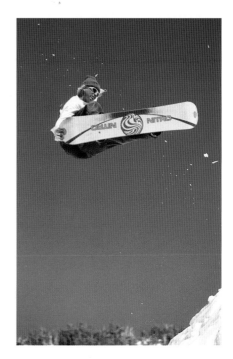

The events at the end of that year would seal a fate that was almost accidentally discovered by Ruben. Rob had just been picked up by the long defunct snowboard company Checker Pig, (probably rivaling 'Crazy Banana' as the dumbest name ever in the industry). There was a huge contest with all of the top pro's of the time competing and Rob was on his way to take part in it. Ruben went along and shot photos of Rob and other pro's. As mentioned earlier, the T.B. series was in it's inaugural year of production and we were always around to go out with them any chance we had. Ruben had also shot a photo of the legendary Damien Sanders and ended up with a spread in the first snowboarding magazine, International Snowboarding Mag. Whether Ruben realized it or not he was quickly gaining recognition as one of the most cutting edge photographers in his field. Destiny had collided with Ruben as he casually moved through it.

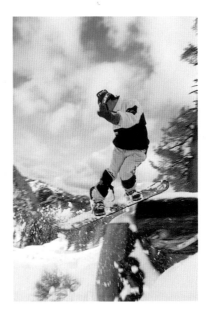 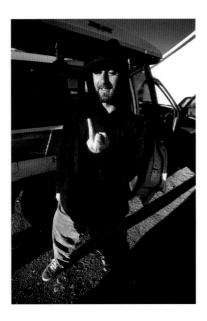 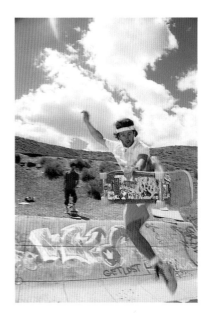 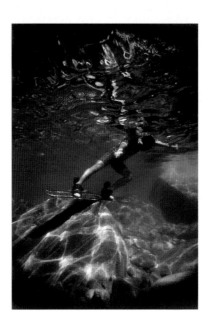

The next year would land our crew back in Incline Village, albeit in two houses now. The word had spread and friends of the original Juanita crew started to infiltrate Tahoe. Sheer anarchy pervaded the scene that next year, and we did not let anything get by us, always ready to pounce on the next challenge. It was natural that Shawn Farmer and Nick Perata joined up with perhaps the craziest member of our crew, Jason Pata. Incline Village, its' young ladies, and even the old fogies were not prepared for what was occurring in their town. We had parties with 'Lag Wagon' and the Hatchett's band 'Fortress of Fear' playing shows in our living rooms. Needless to say, the cops really loved us. Through it all, Ruben somehow remained focused on the business at hand. We both worked at Diamond Peak, (Incline's local resort) shooting photos of tourists with beautiful Lake Tahoe in the background. However, Ruben stuck to shooting more important photos, images of people excelling and progressing in our sport. Overall, there was a sense that there was nothing we couldn't do. In that same year, Tim Manning joined forces with us and the circle was complete.

To spend too much time thinking about the past is to live in it. Although identity is lost if your reverie and respect for the past go unrecognized. The adventures and the participants of those times were shaping what was to become the rock star sport snowboarding evolved into today. The times were changing, and all around people started making money on snowboarding and the infiltration of the people who did not know the sport began. One of the best things about that time was the fact that the lines between skateboarding and snowboarding became indistinguishable. Companies and athletes from both camps became united much to the schgrin of the 'ski industry'. During this period, it was easy for us to separate the 'real' from the imitators. There was one group that was just out for the quick buck, and they were actually the one's trying to fit snowboarding into a nice shrink wrapped package, fulfilling their desires for the mainstream push. However, there was another group, who understood the sport, and started from where their hearts had lead them. This clan was responsible for maintaining the excitement from which snowboarding was born out of.

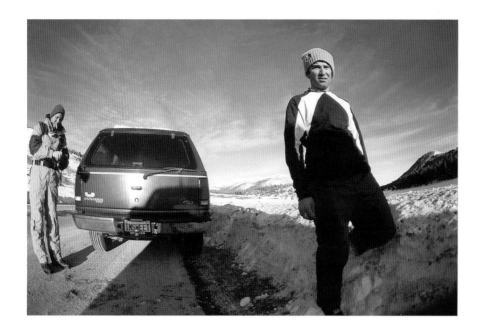 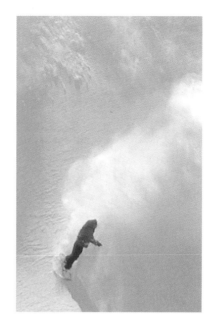 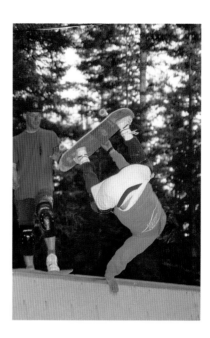

As film crews documented the movement, sponsors as well as riders needed images of those precious moments. Ruben was now in the perfect position to lend his insight. At that time there were people who knew nothing about the sport, shooting photos of snowboarders. This was perfect, because from day one, Rube was a snowboarder. The images produced from an eye that knows, greatly differ from the images produced by an outsider.

As for the rest of us, we held down the fort and continued with the good times. Our awareness of the spirit that ingulfed us, brought us into contact with skilled riders from other parts of the country, leaving us with long lasting friendships and incredible experiences, some that are chronicled in this book, others that remain in our minds and hearts forever. This was a monumental time, and none of us realized how much we were growing through these special years. It was like Magic Mountain, except these were real mountains and the rides we had discovered were created solely by our imagination.

Imagination blended with a spirit of adventure creates knowledge that cannot be learned through the pages of a book. This spirit fills us and dictates the course we will follow on the road of experience. Throughout the past decade, monumental leaps have been created and documented, producing an illustrious trail of images for us to behold. More than just snapshots of passing fancy, the pages of this book represent the spirit that fills us every time fresh snow blankets the earth or the ocean swells provide another day of aquatic enlightenment. This is an embodiment of moments that are now gone, but in passing, have created an energy that encompasses life itself.

-Israel James

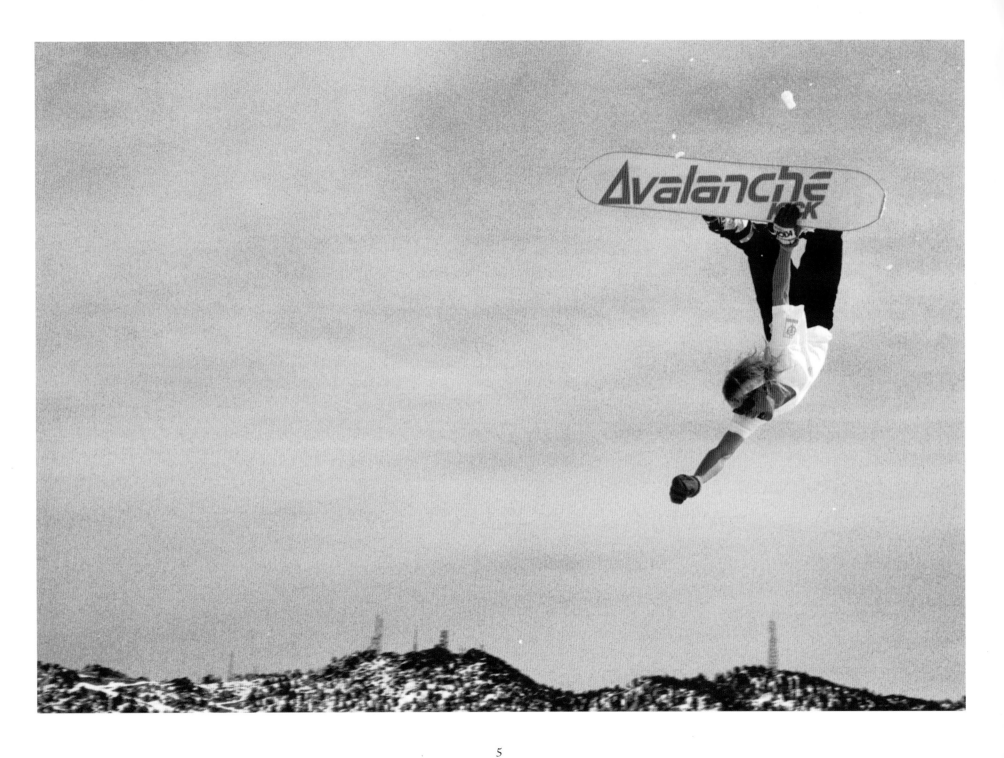

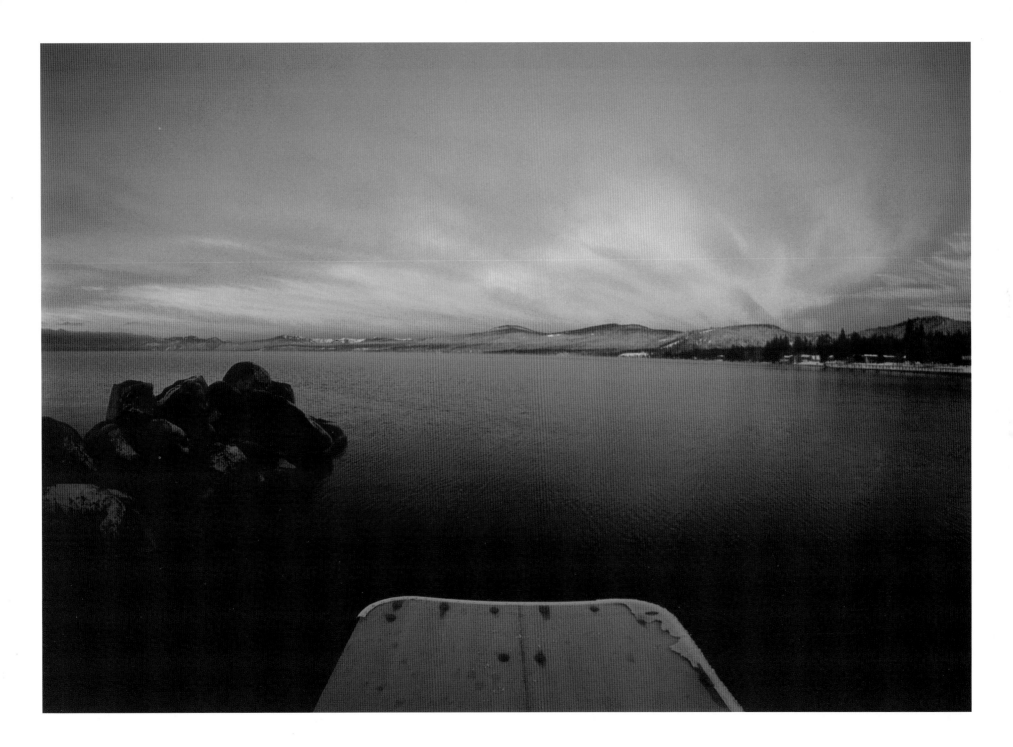

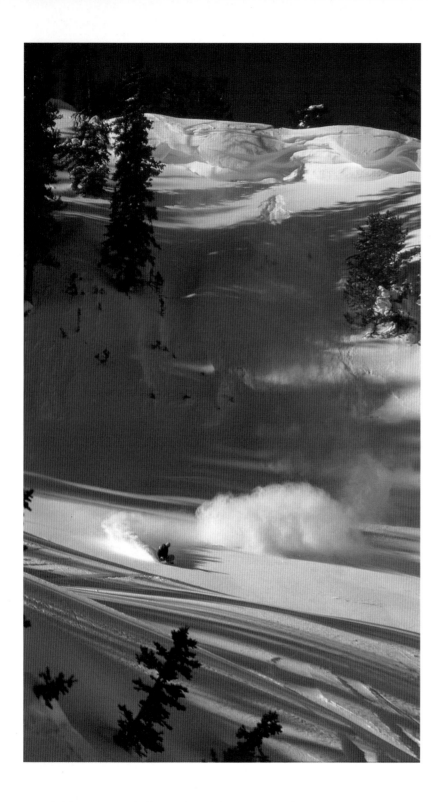

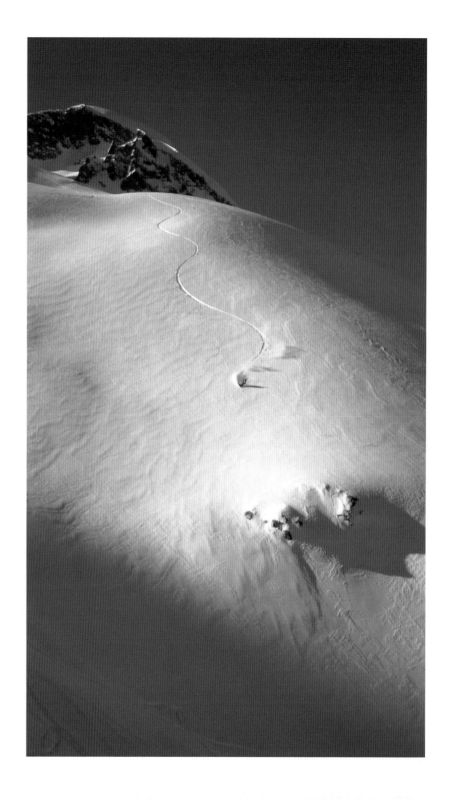

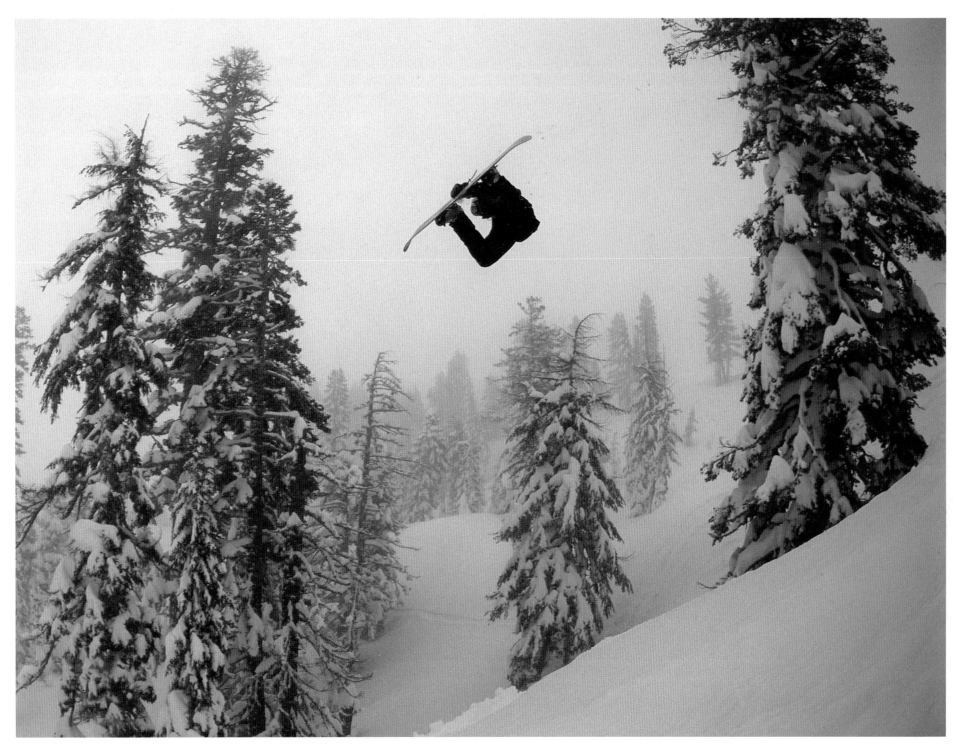

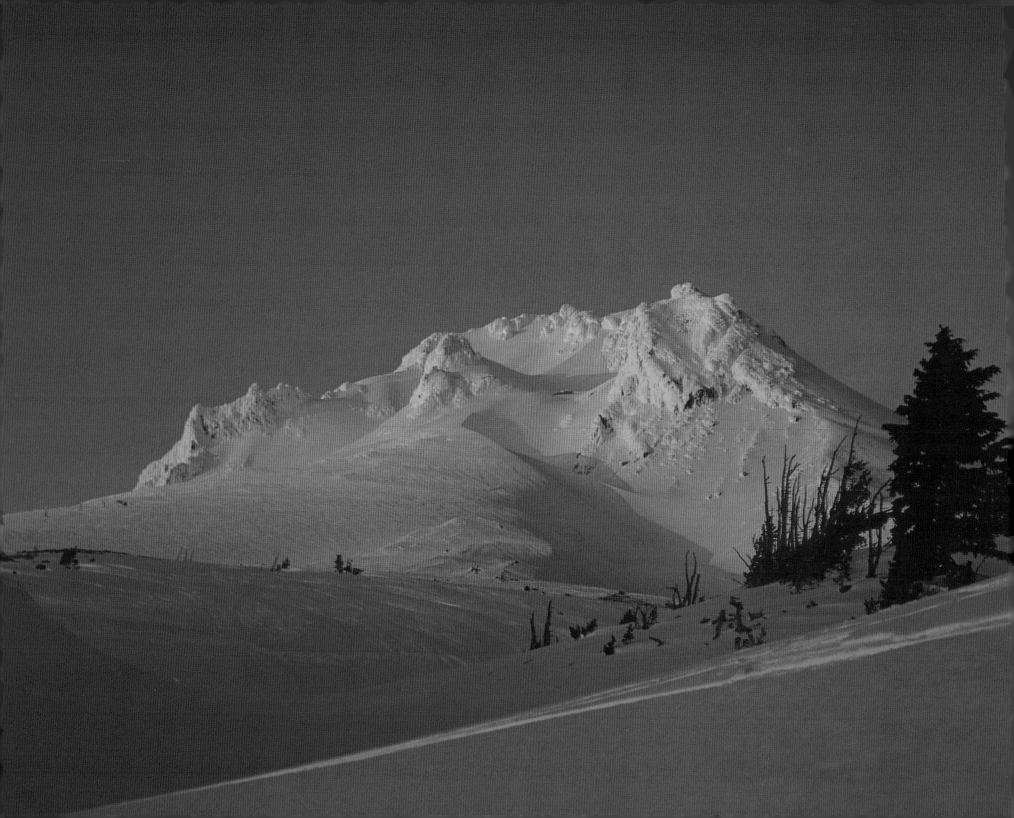

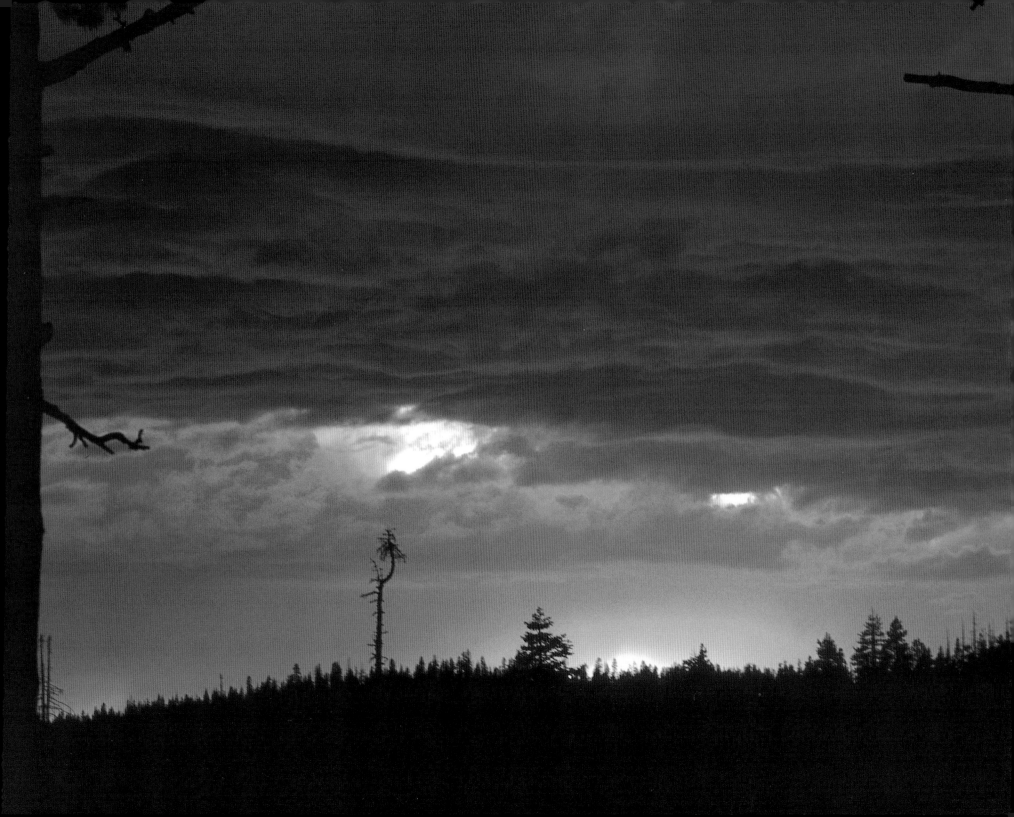

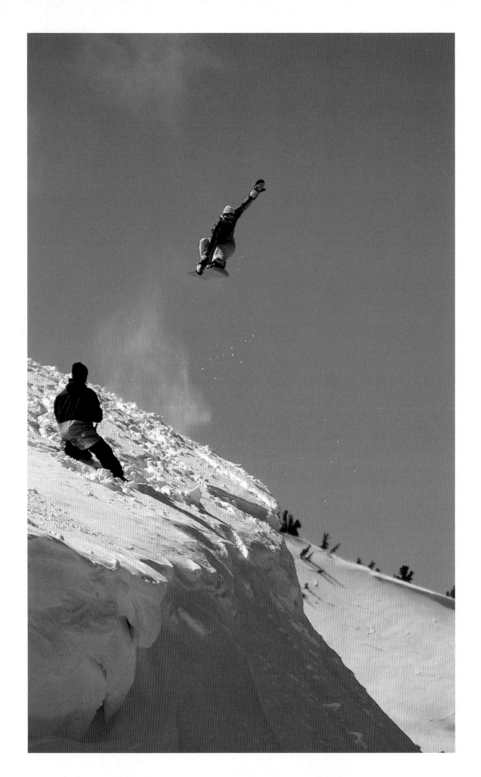

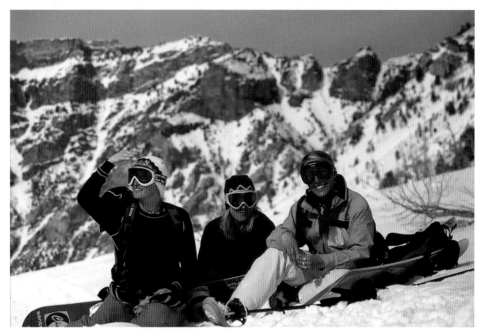

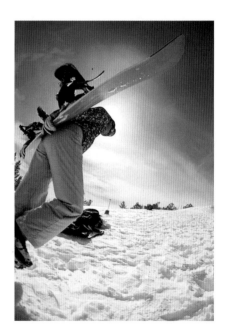

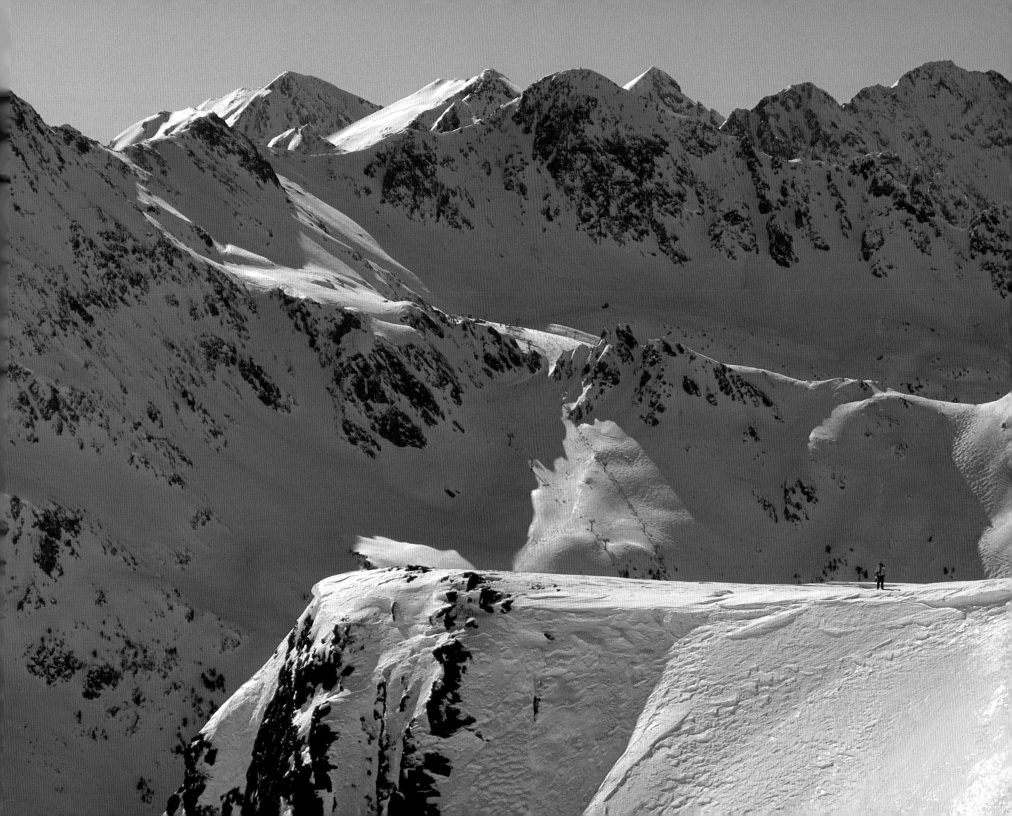

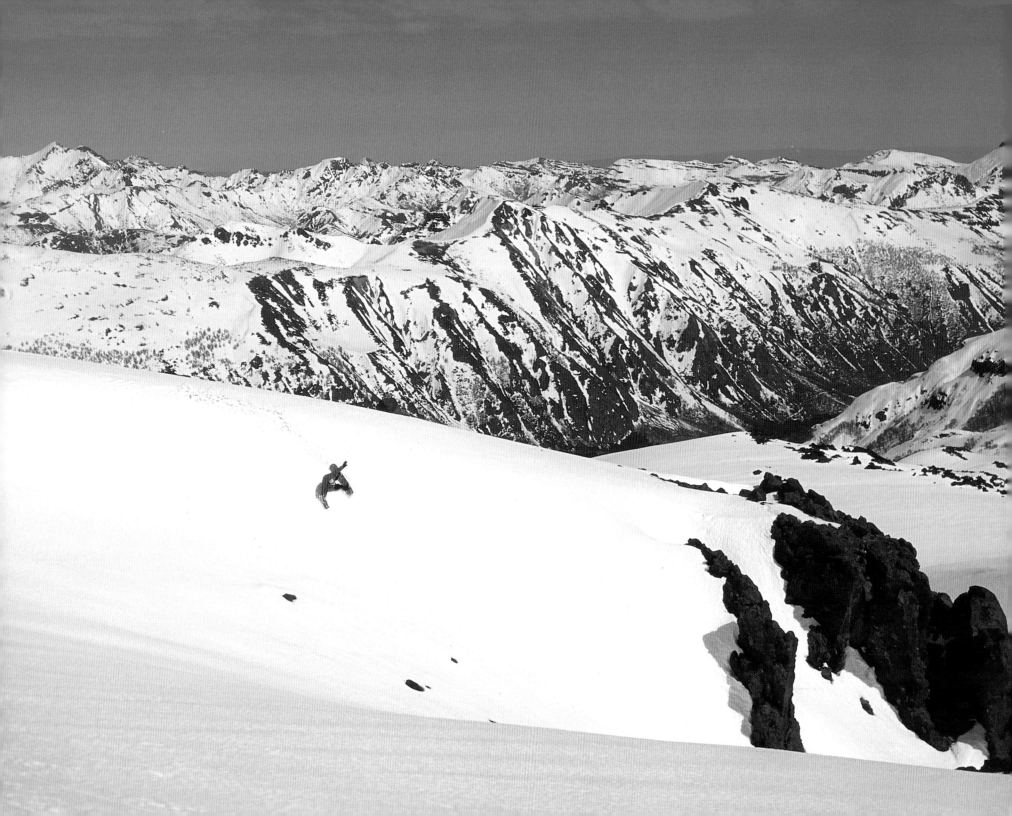

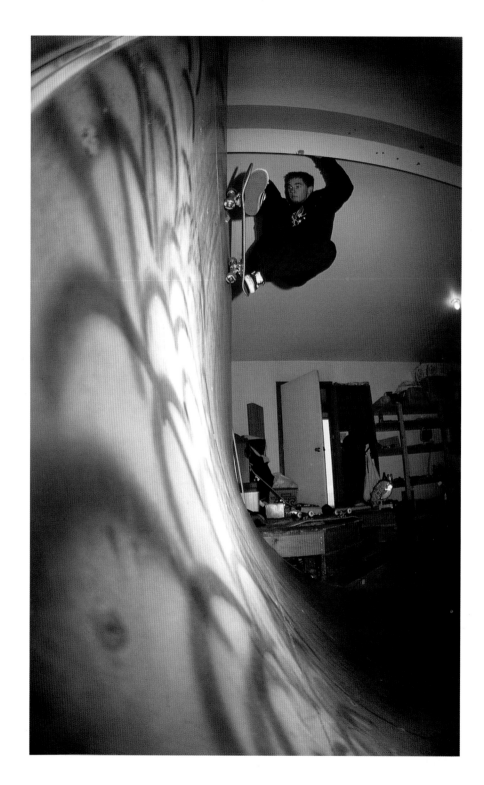

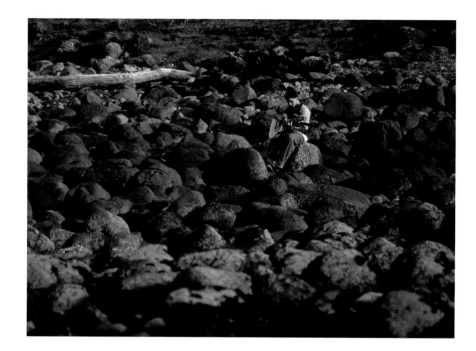

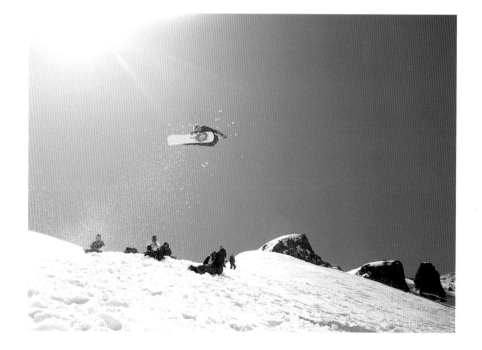

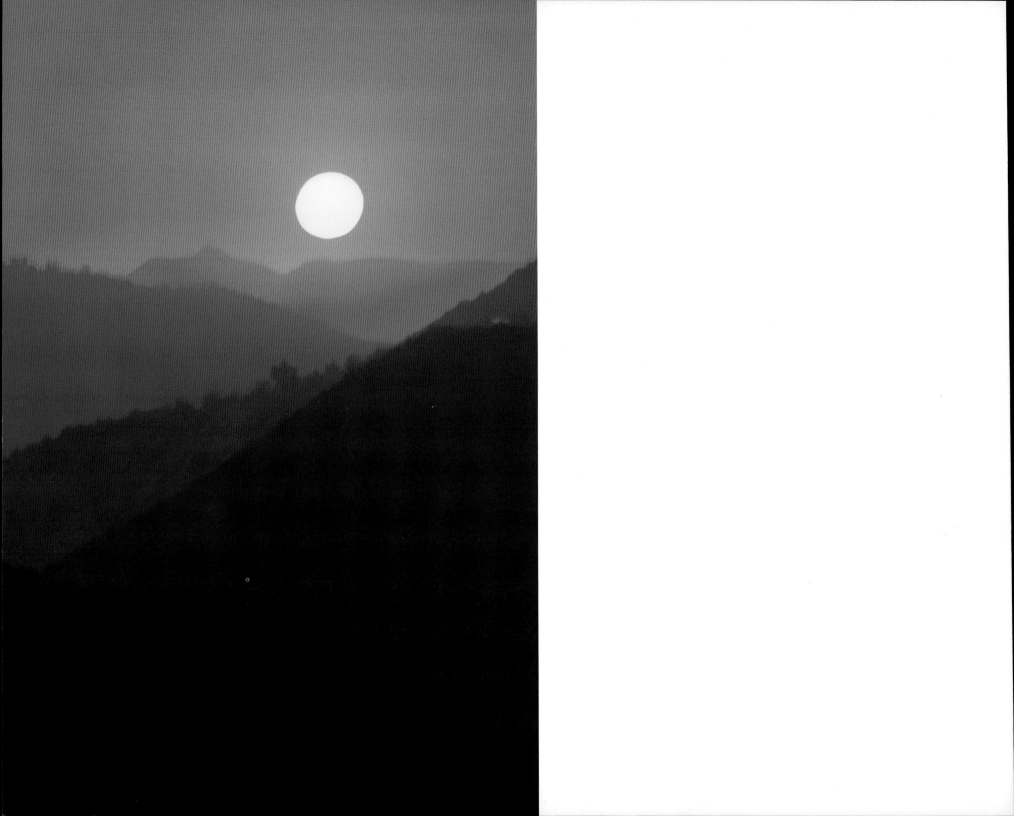

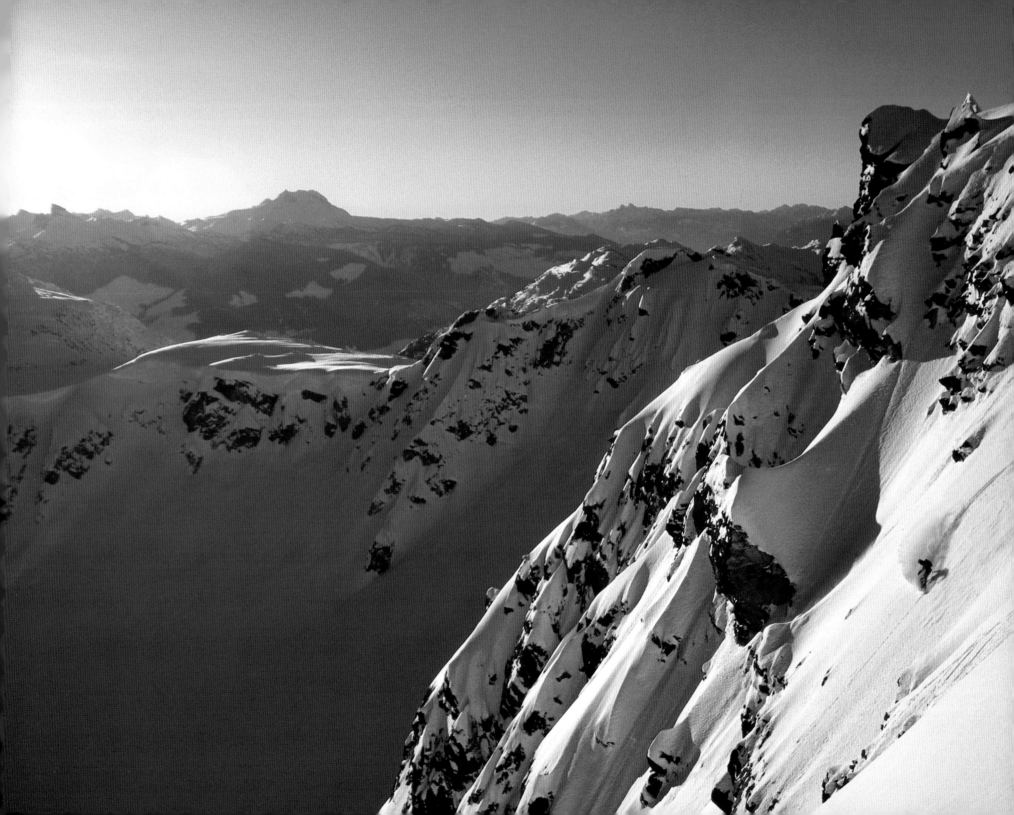

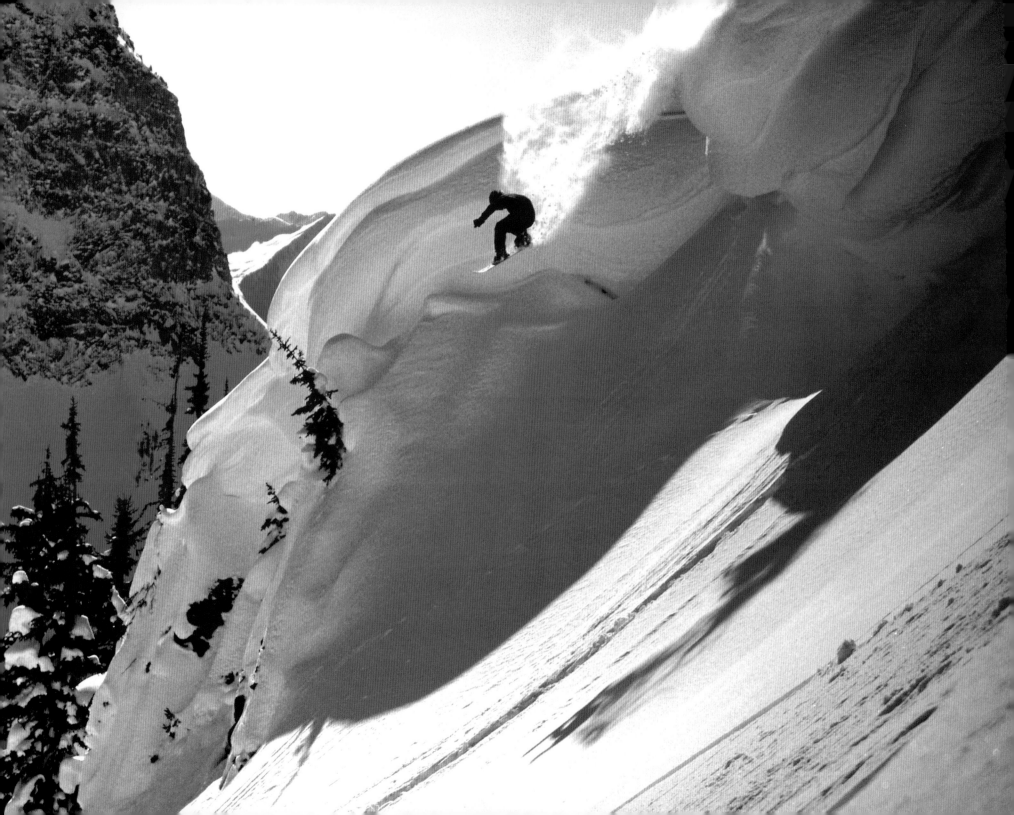

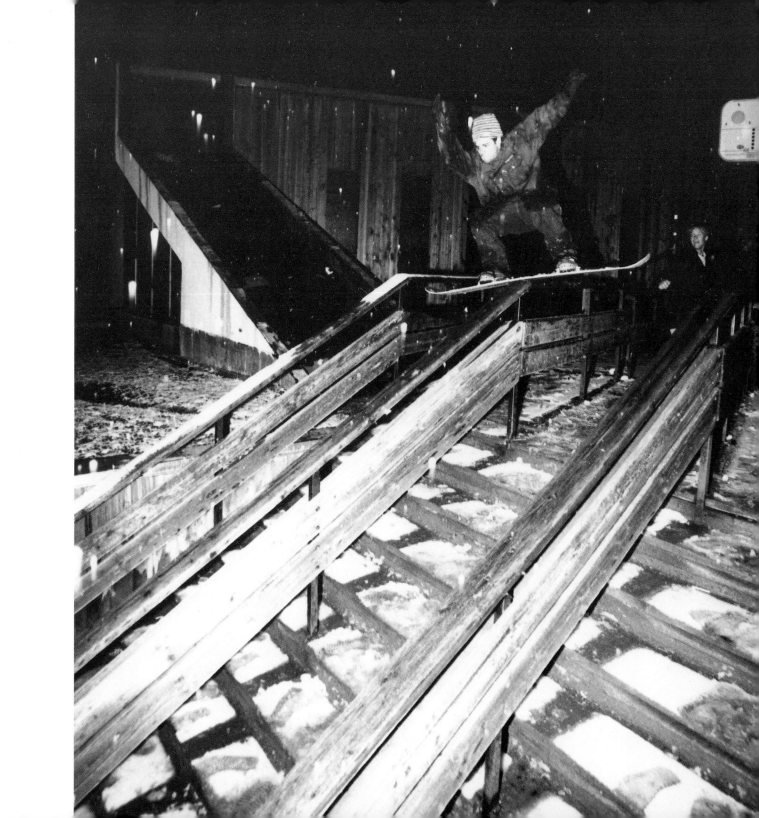

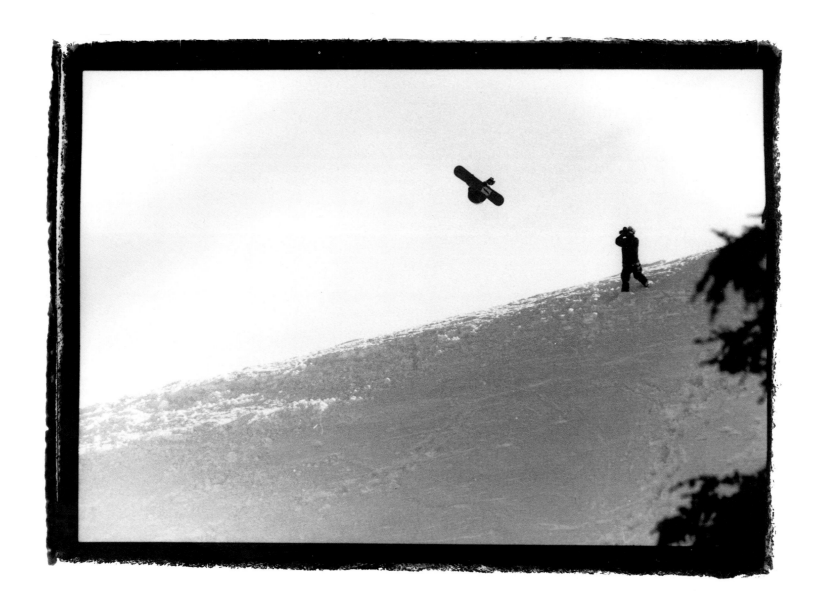

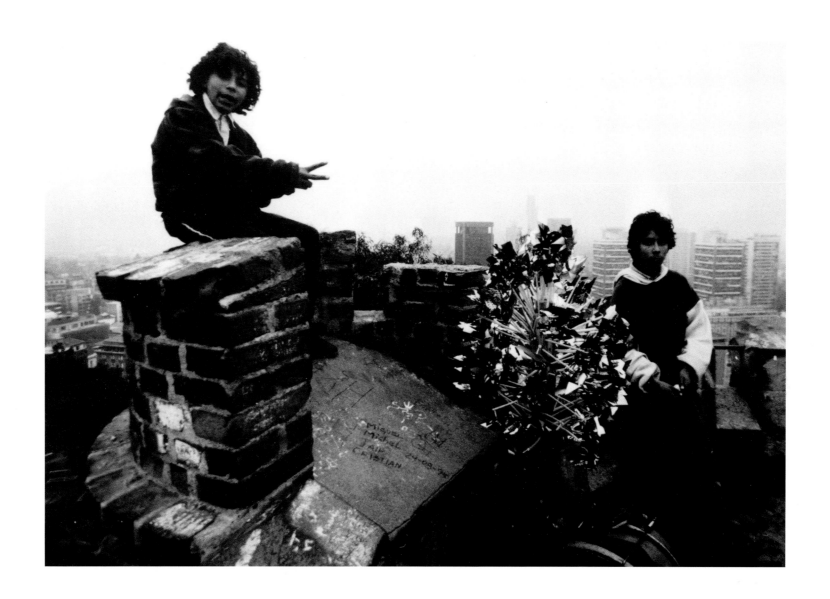

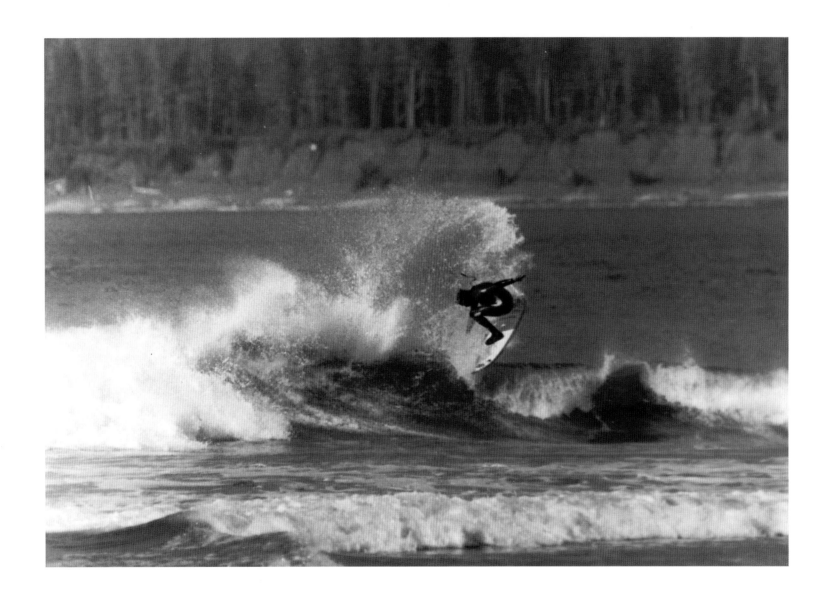

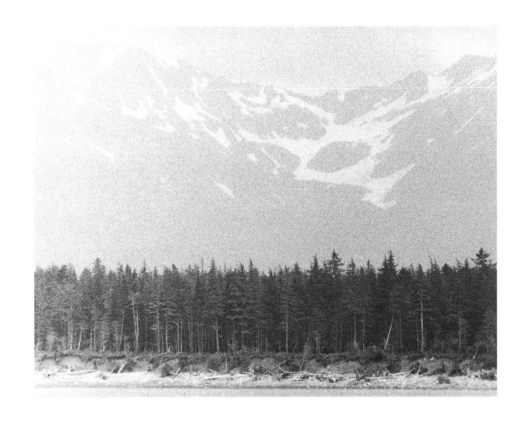

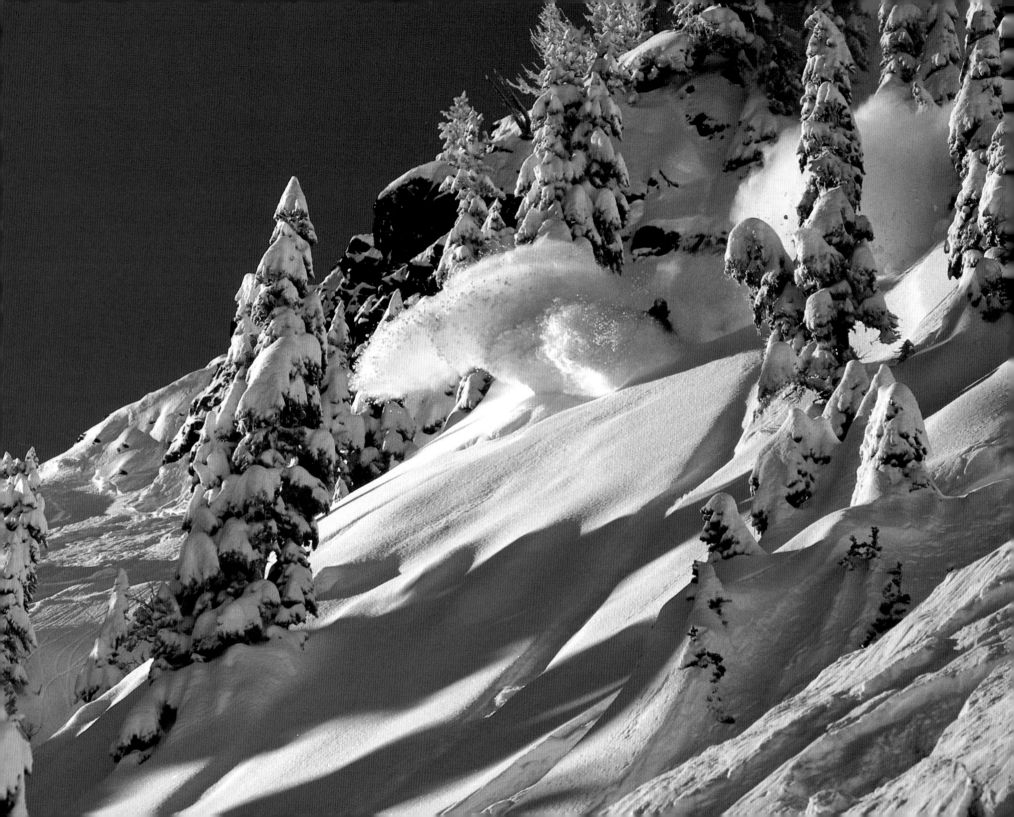

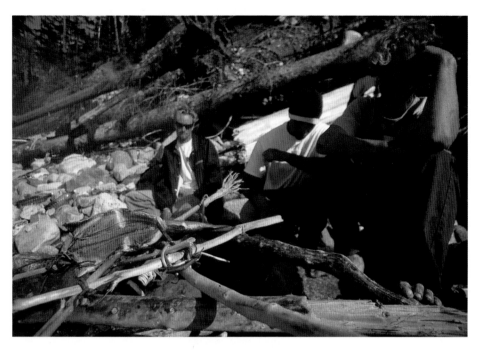

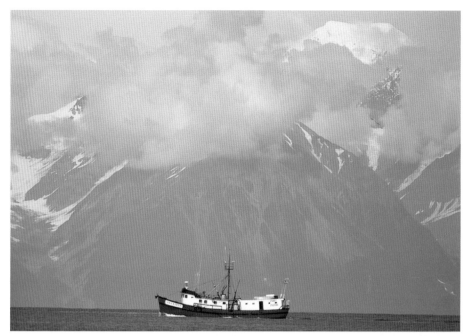

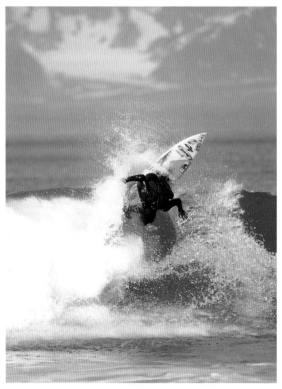

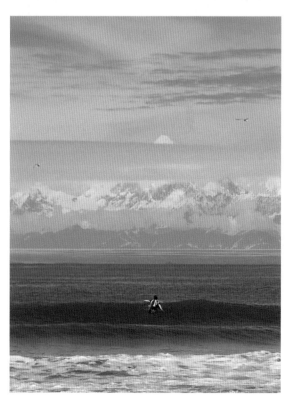

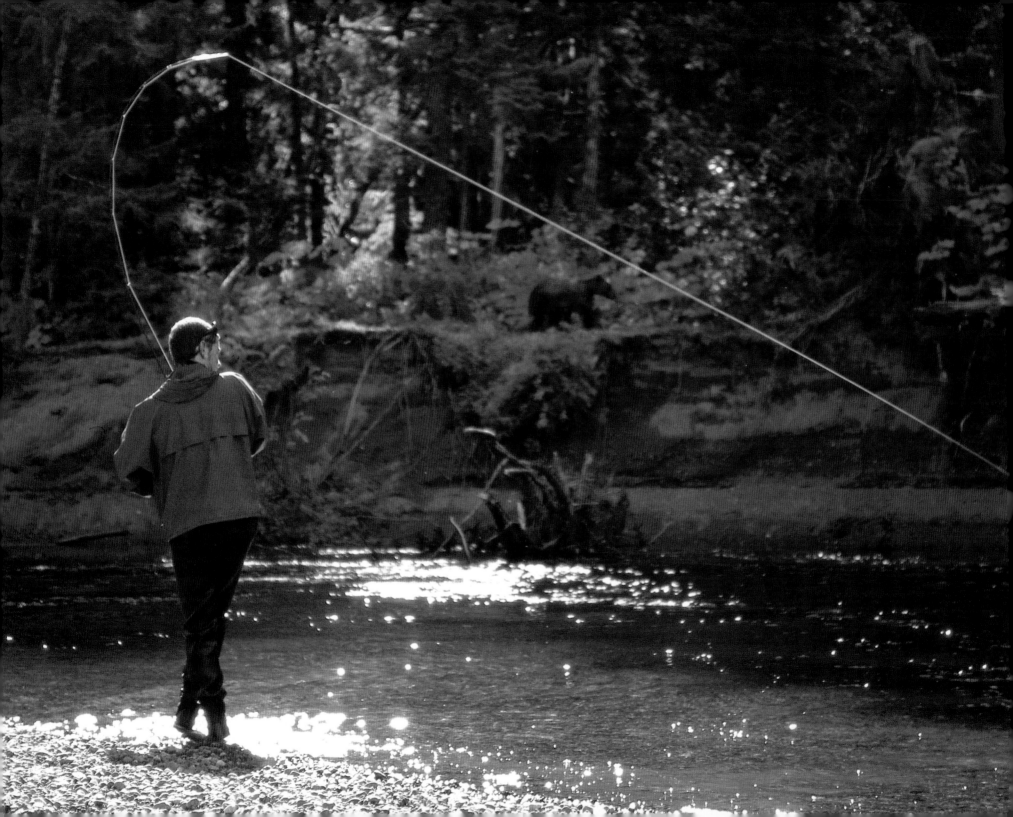

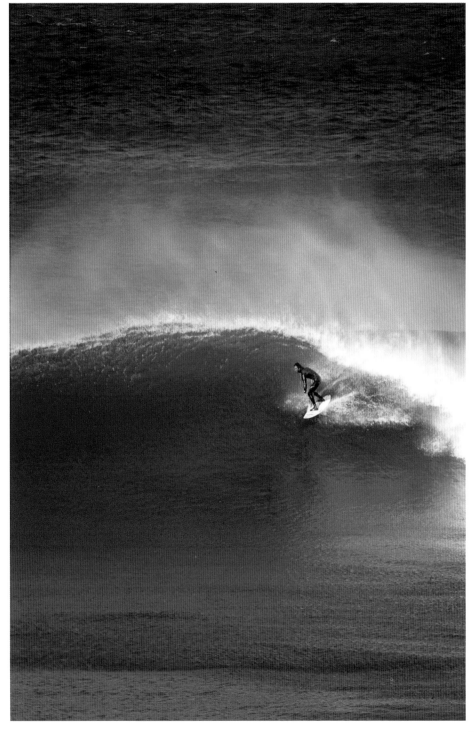
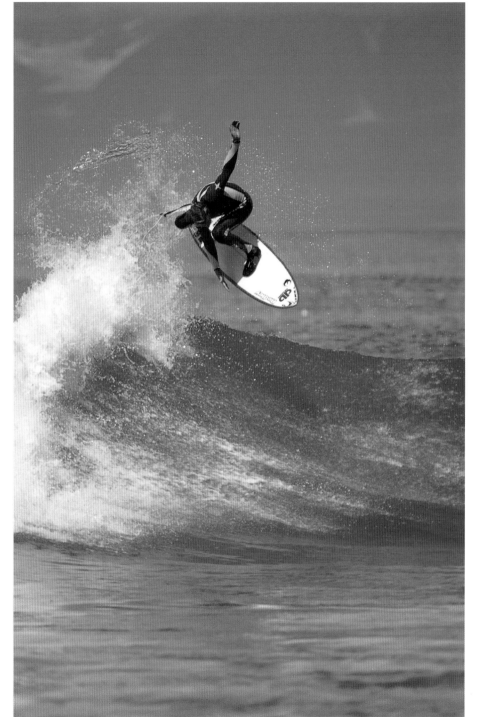

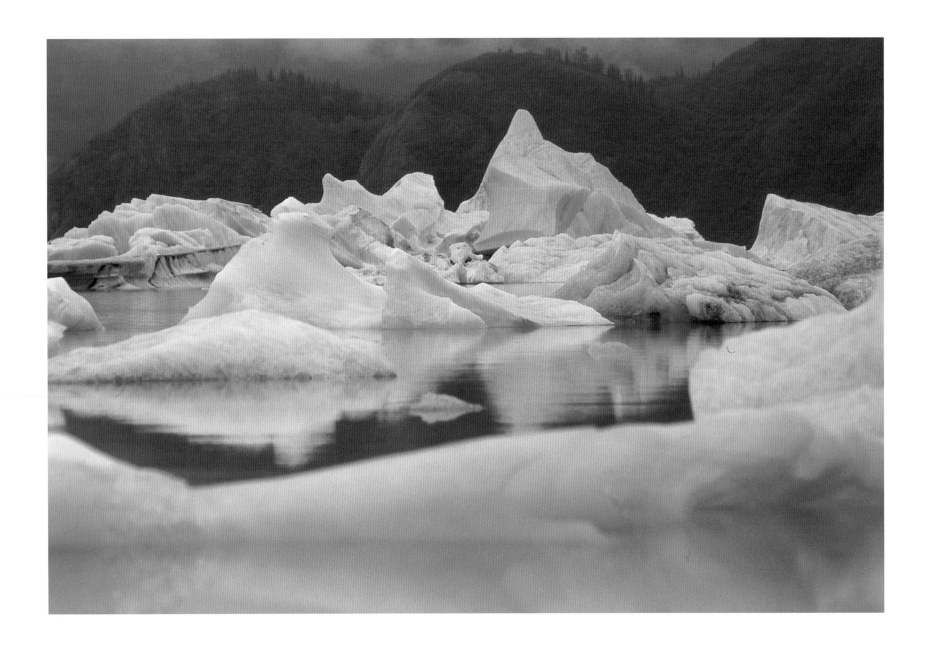

1

2

3

6

7

4

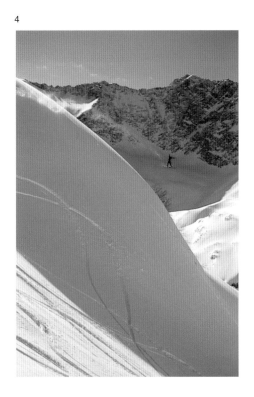

5

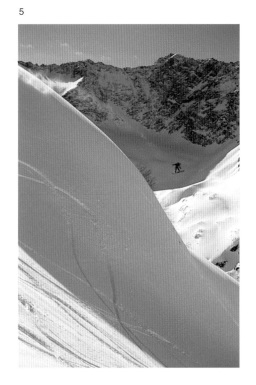

8

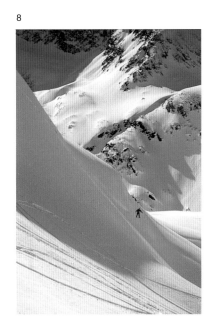

9

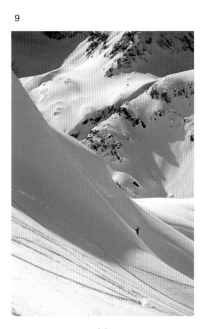

10

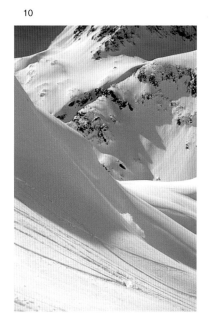

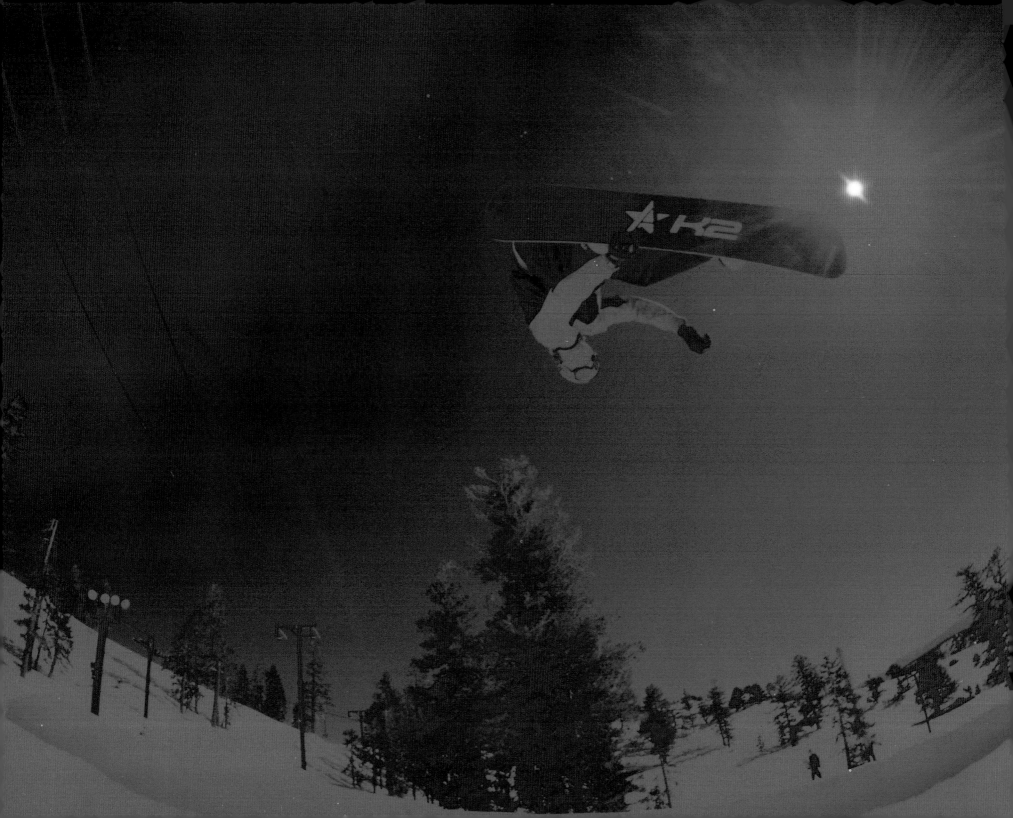

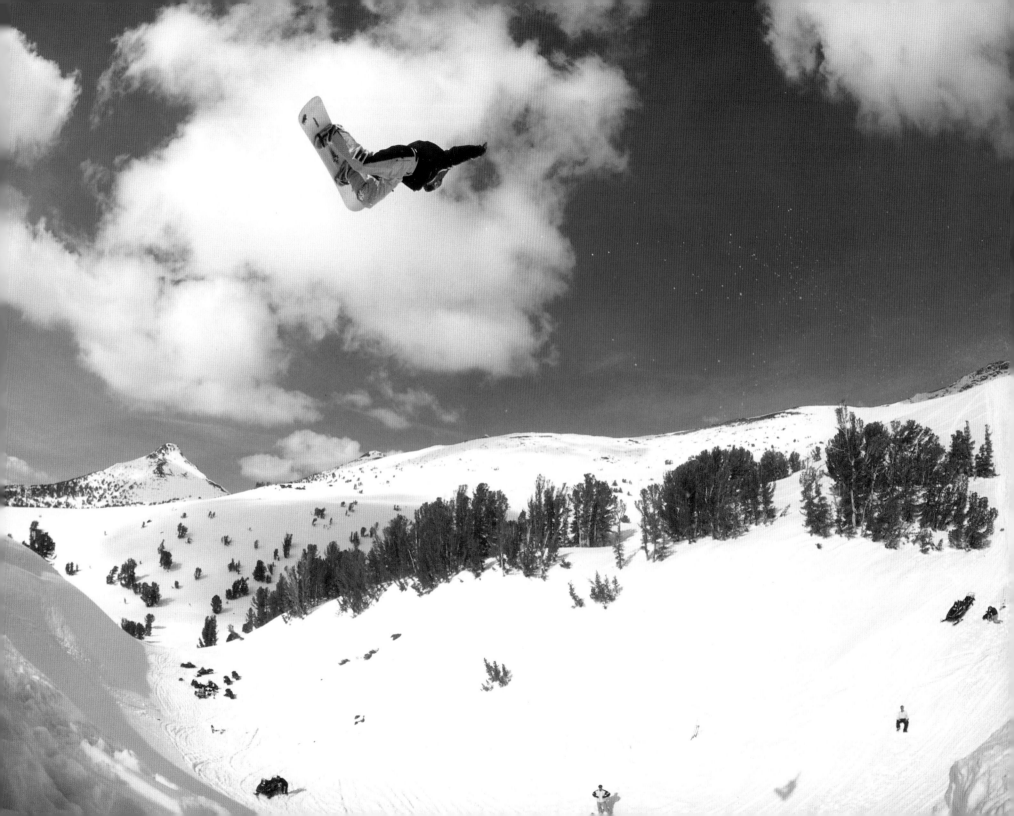

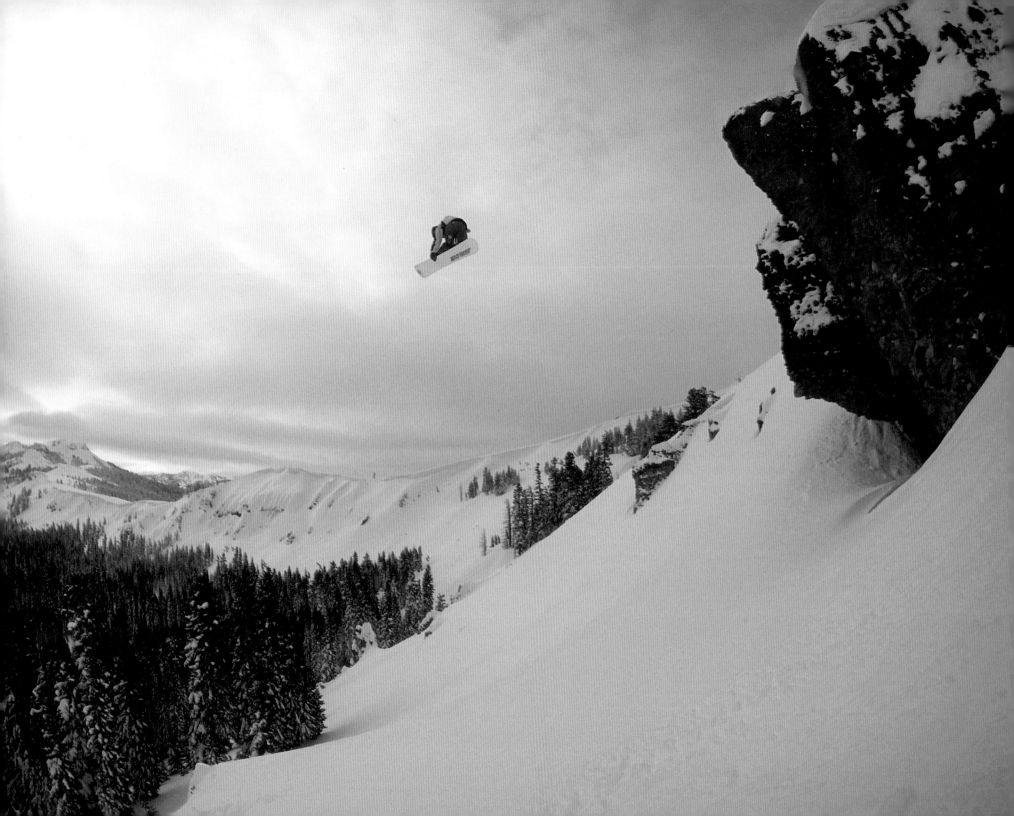

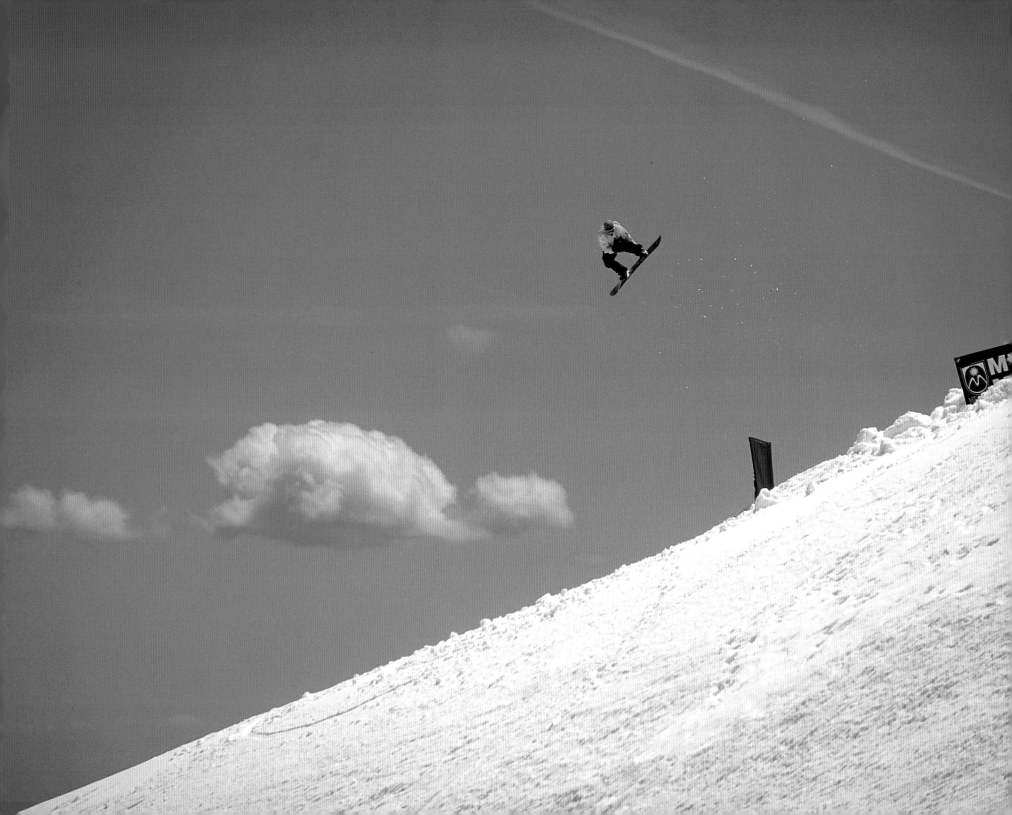

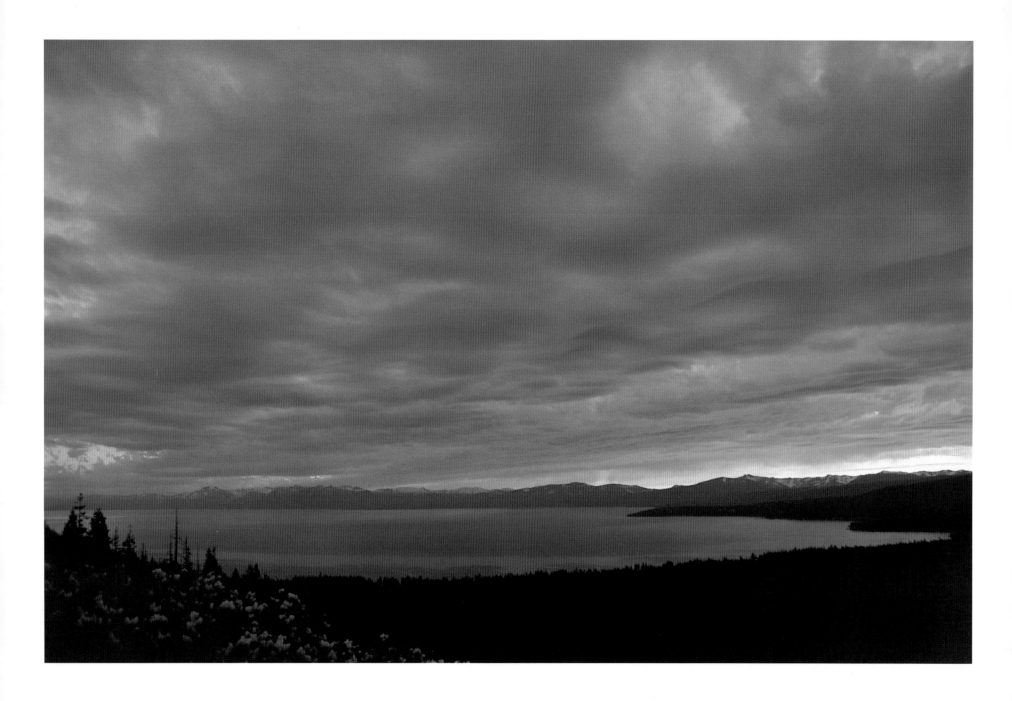

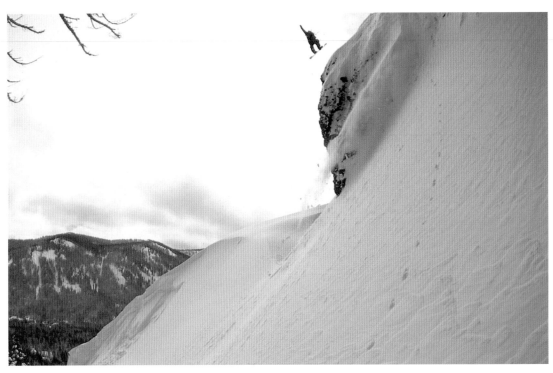

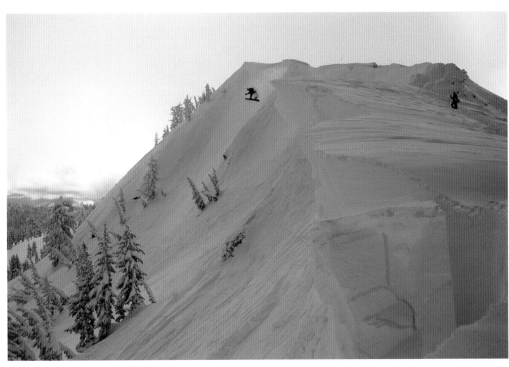

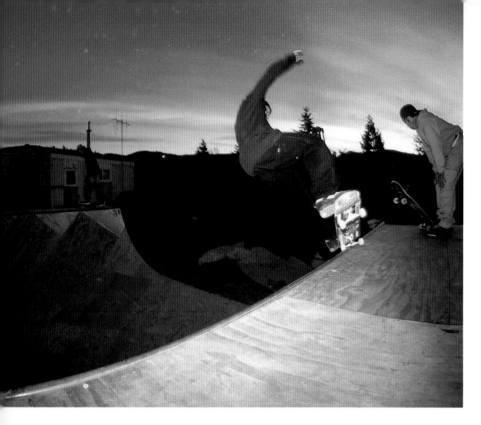
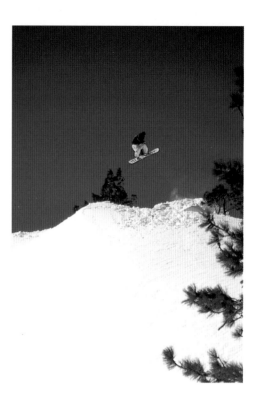
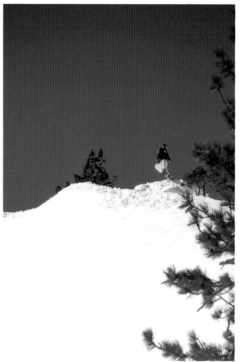
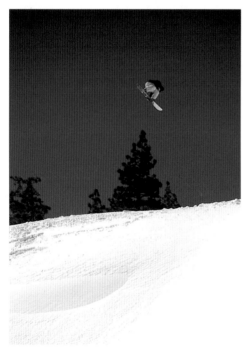
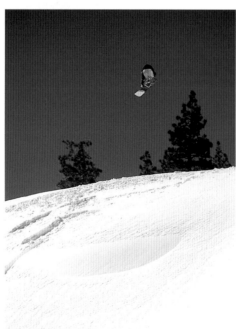
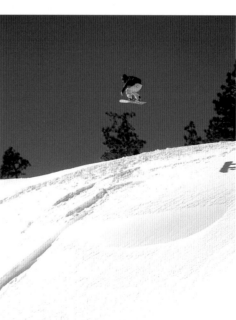

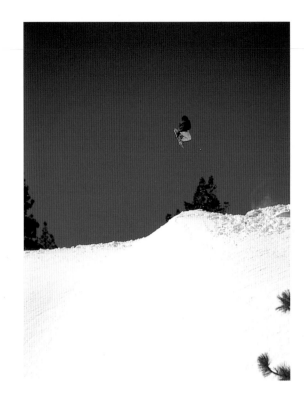
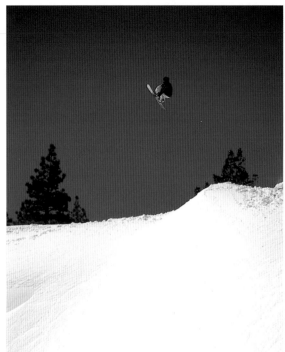
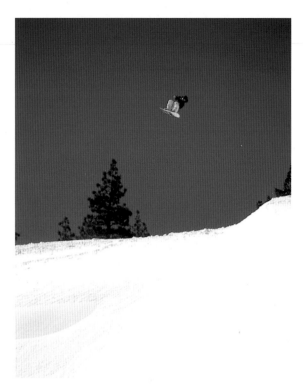
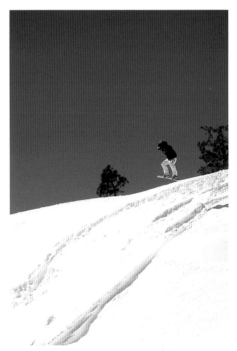
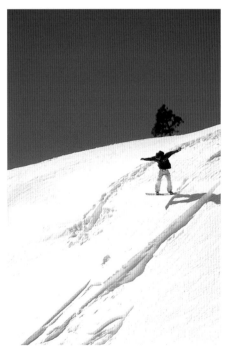
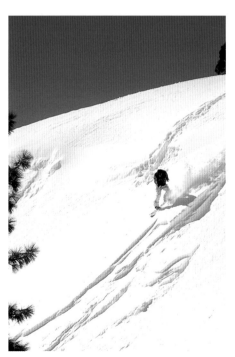
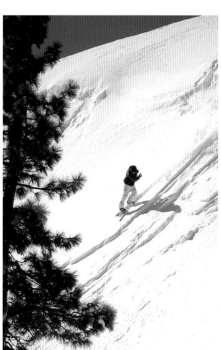

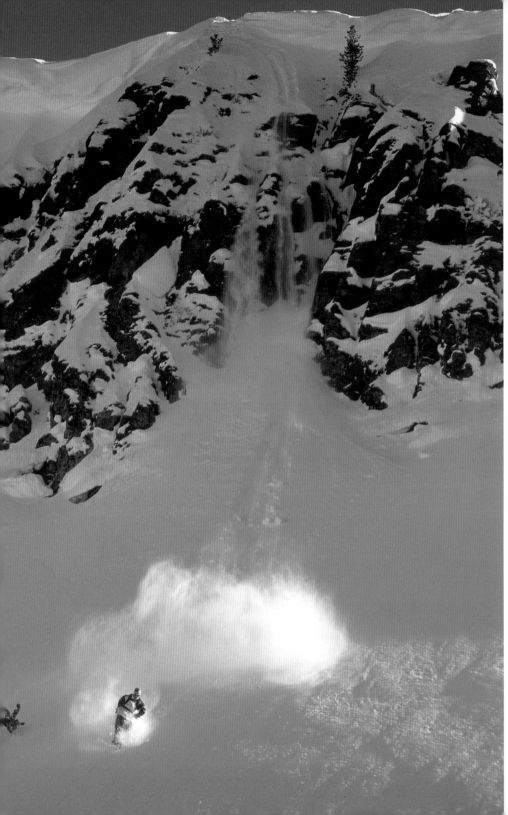

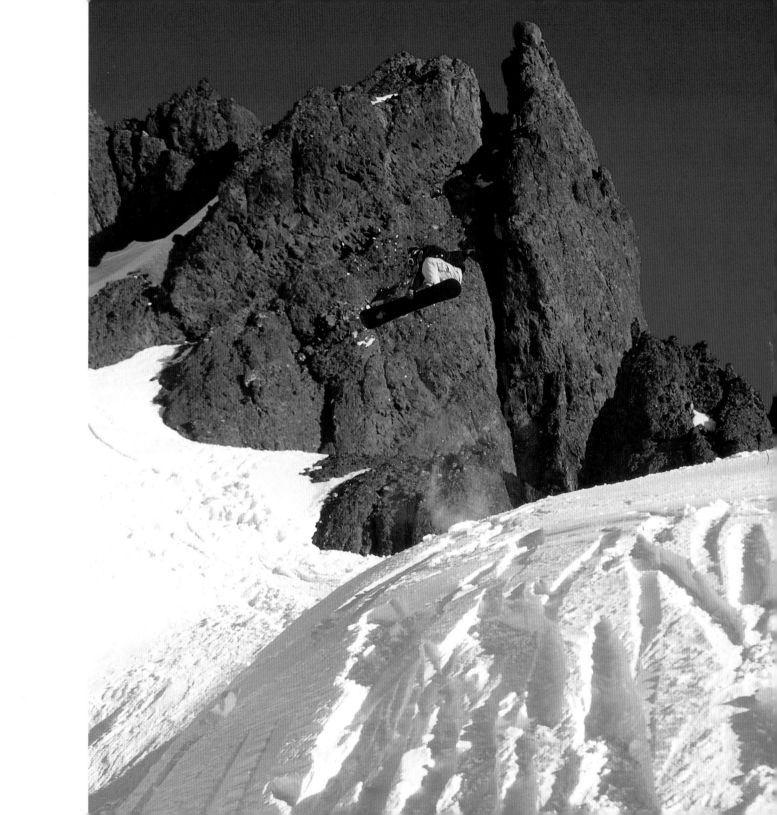

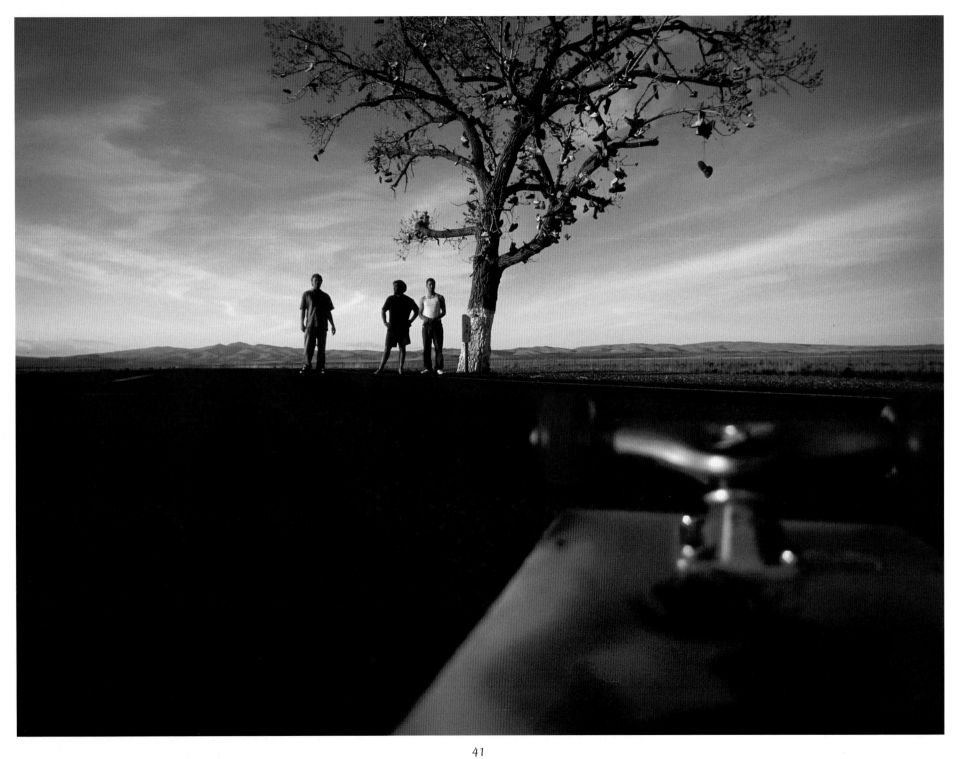

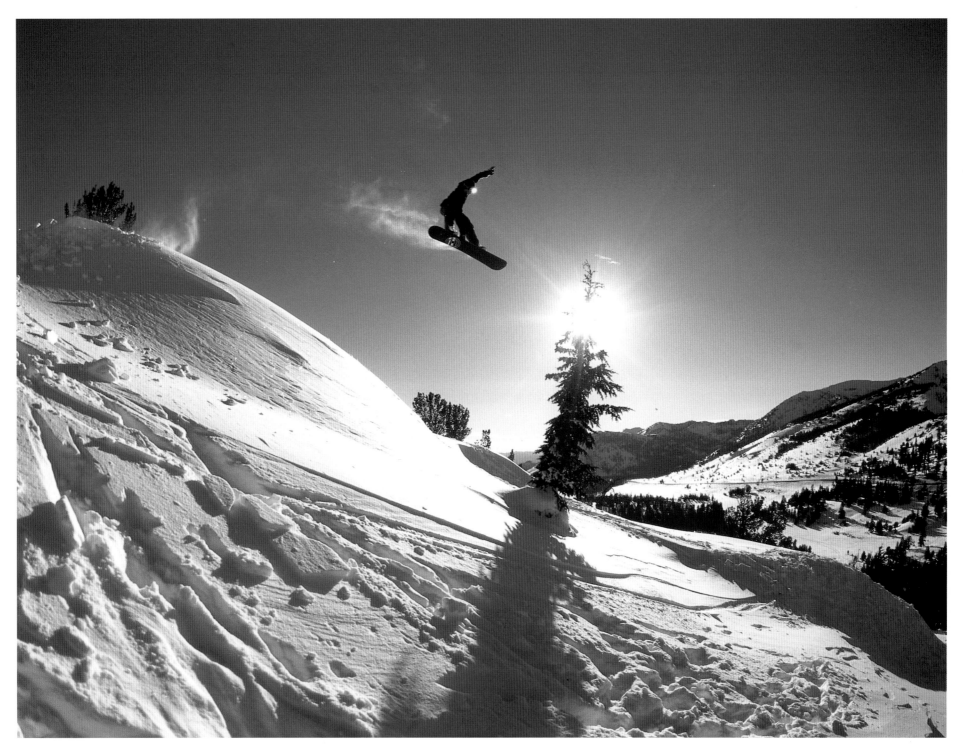

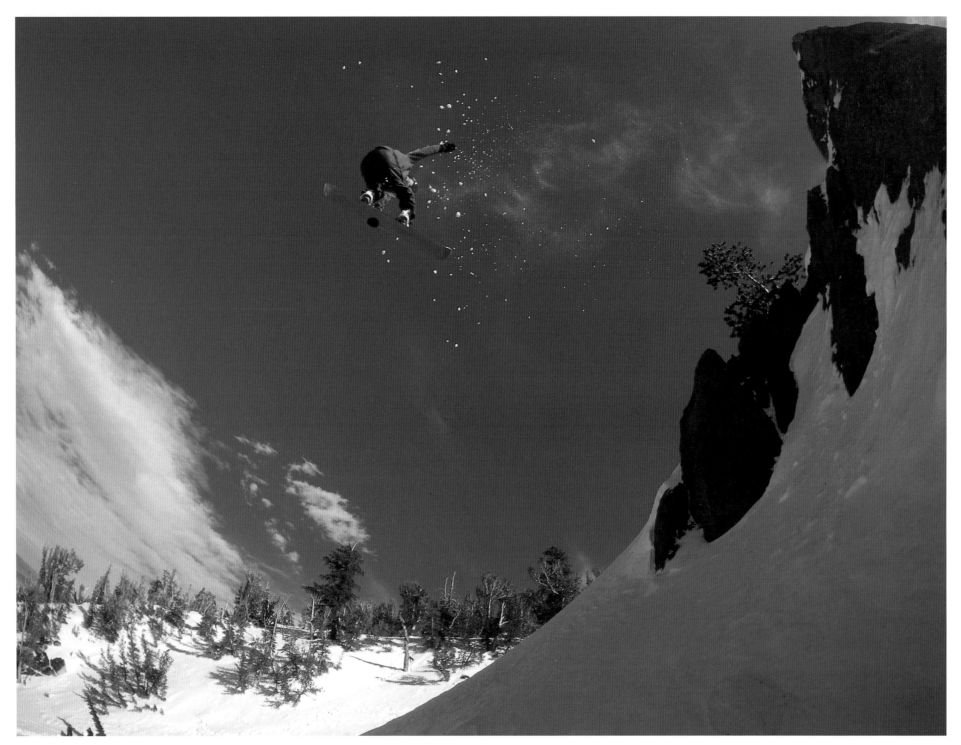

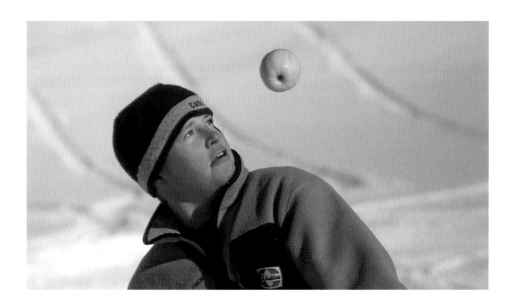

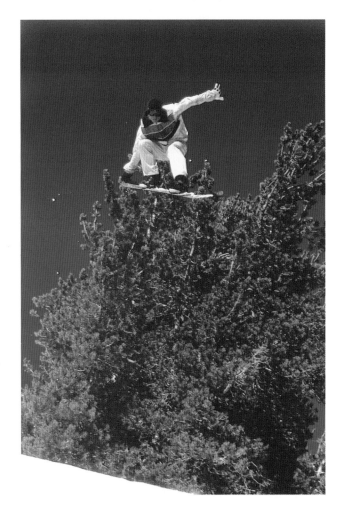

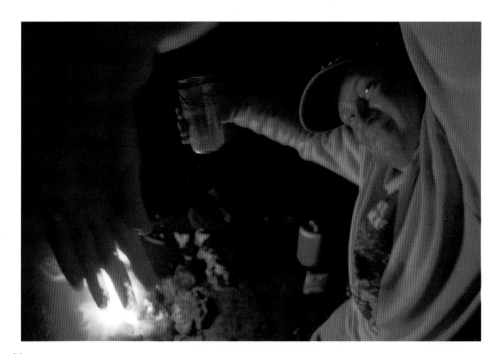

44

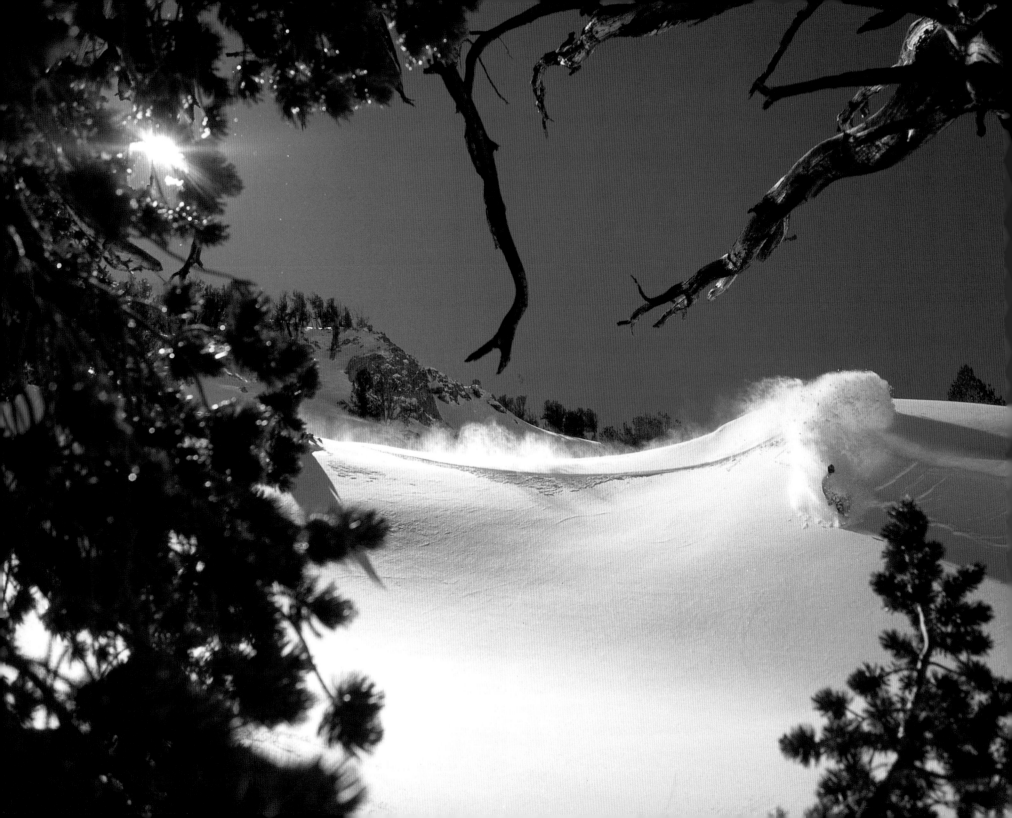

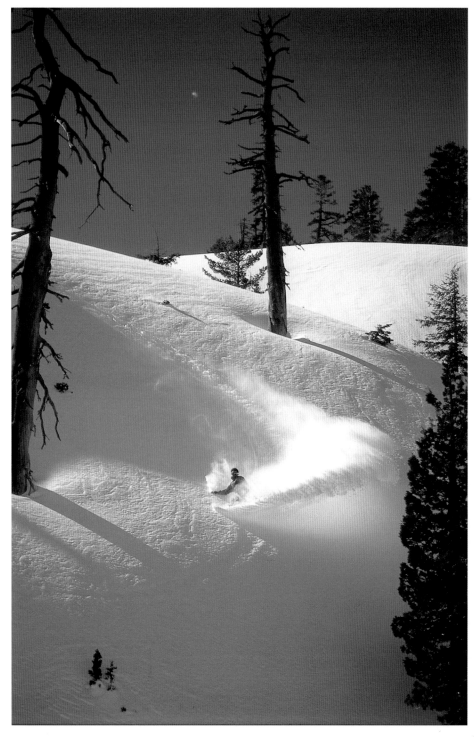
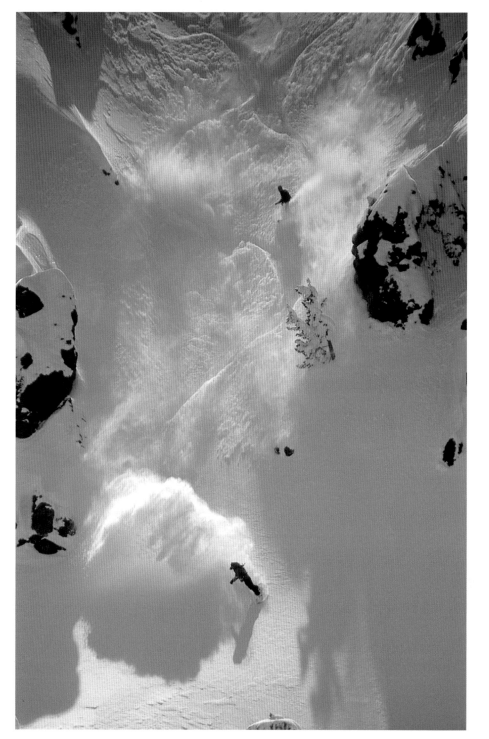

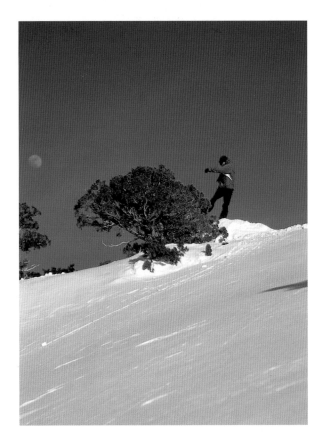

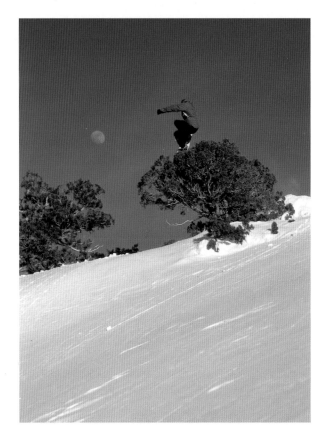

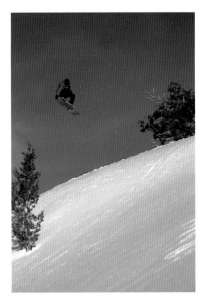

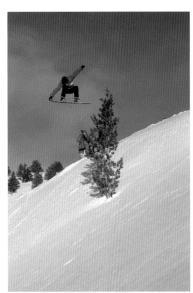

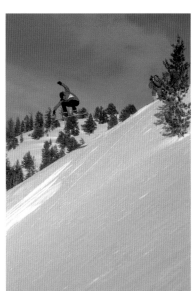

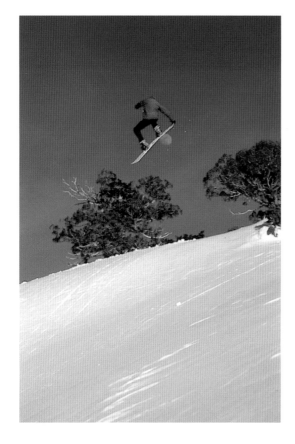

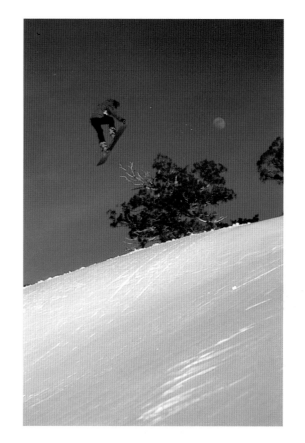

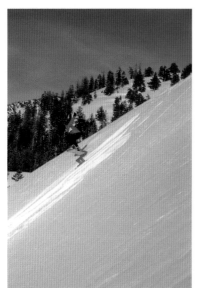

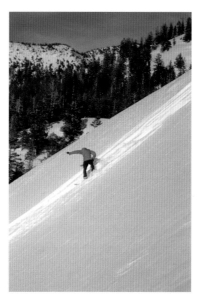

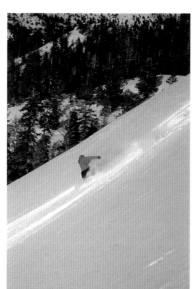

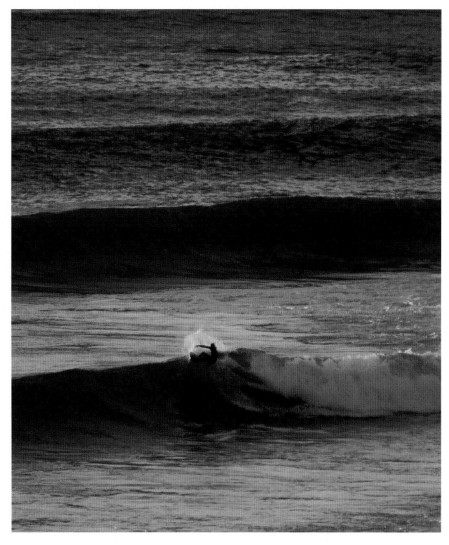

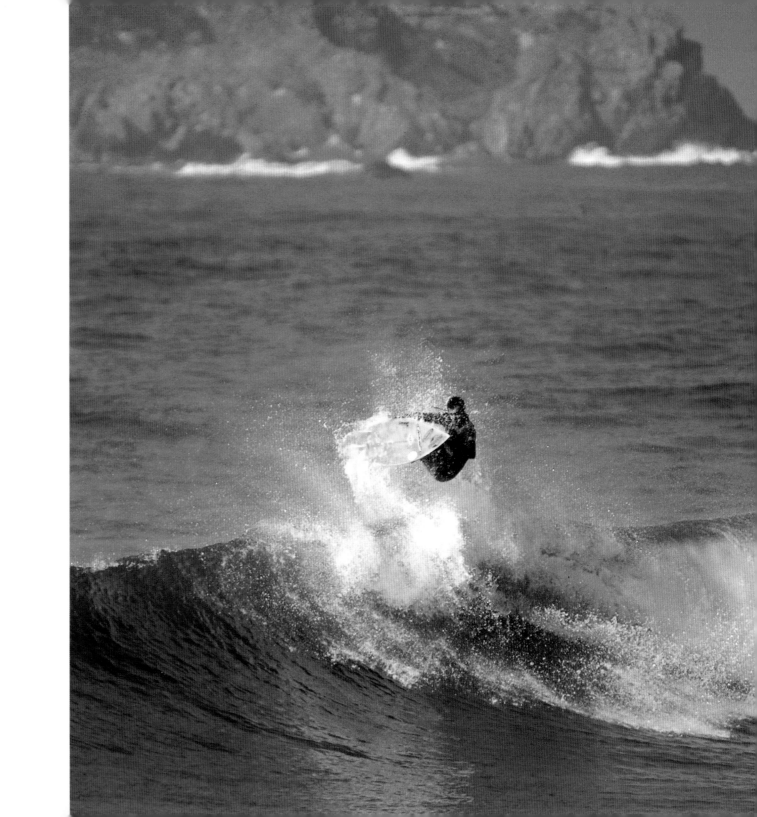

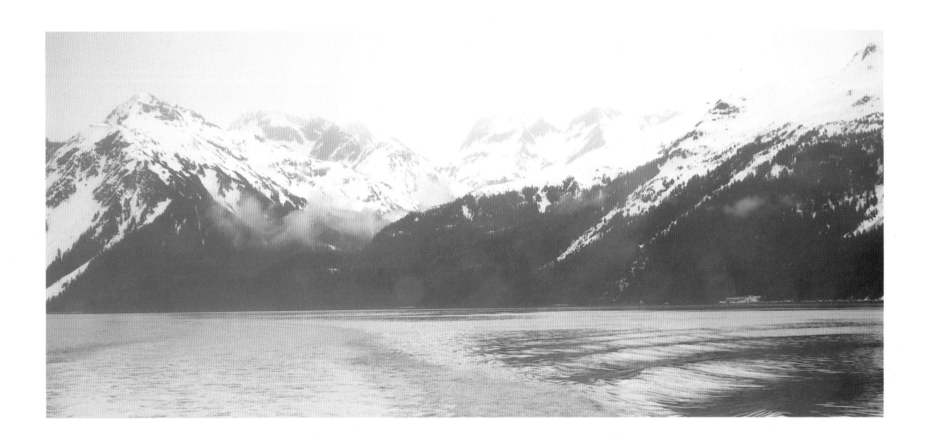

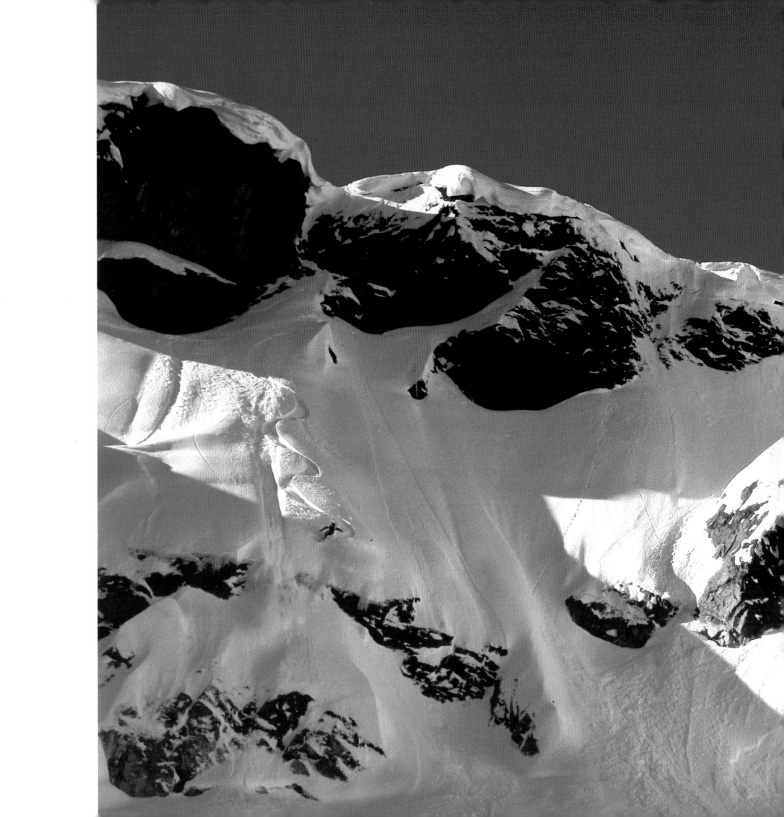

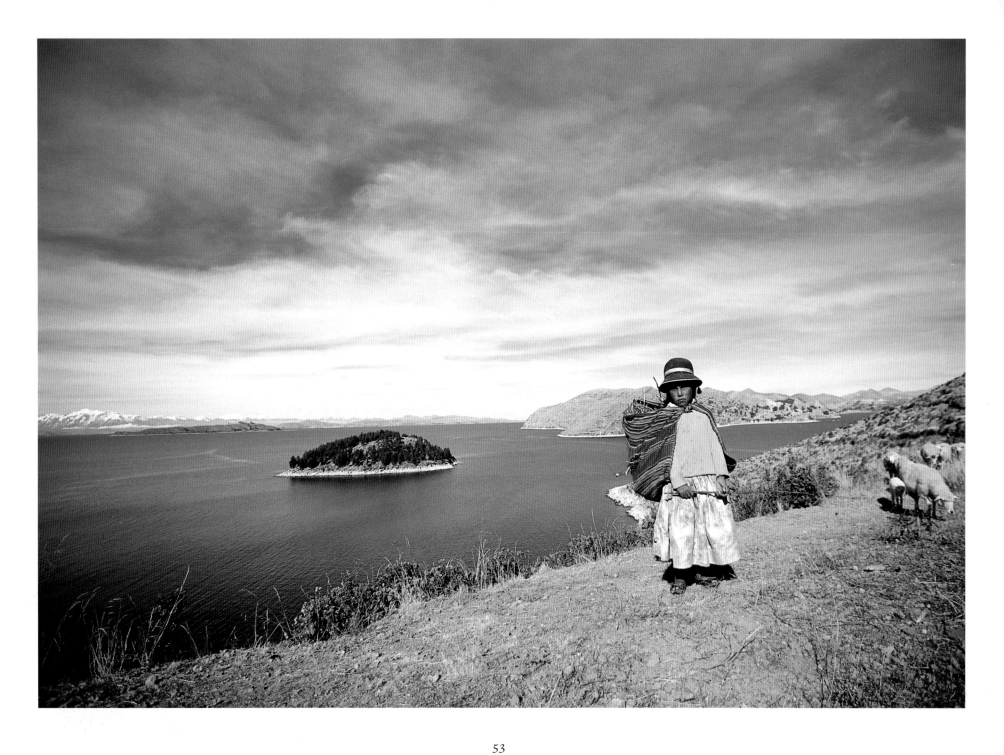

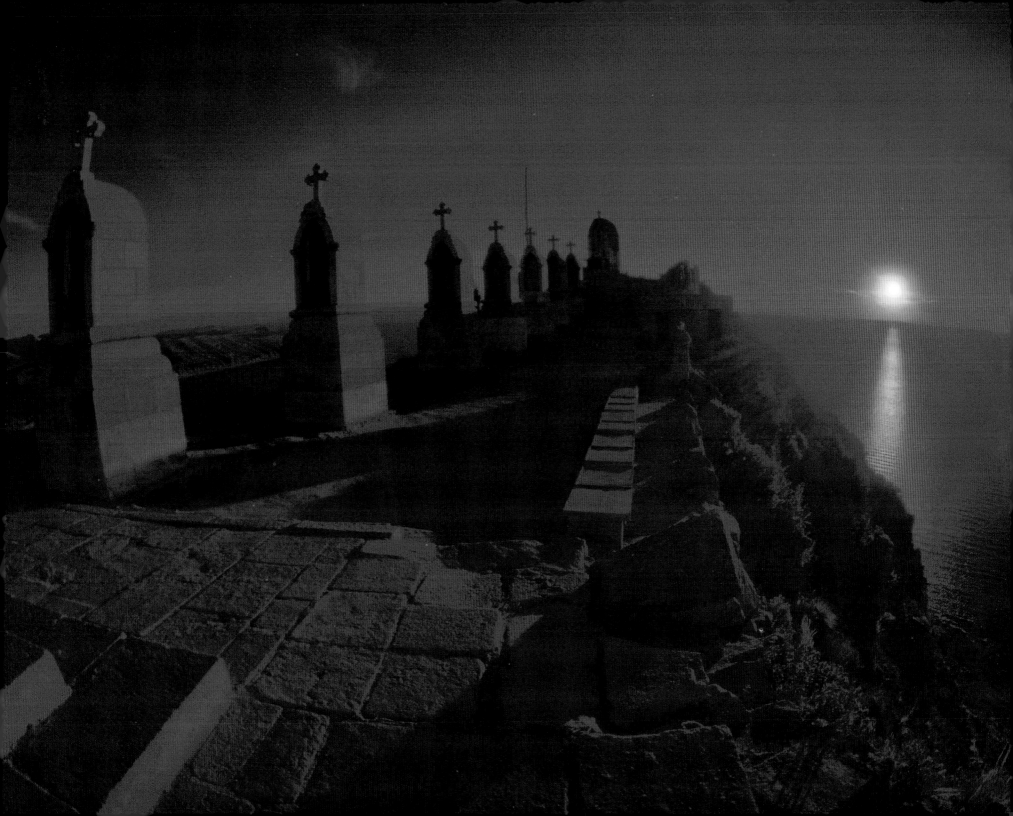

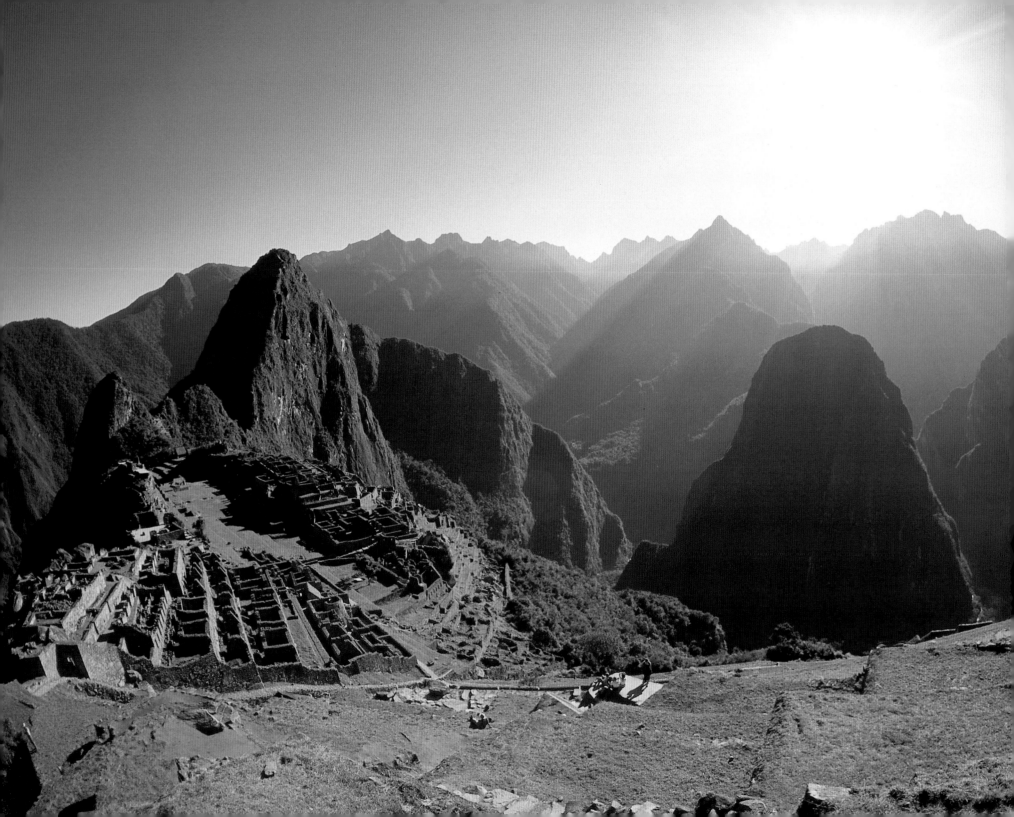

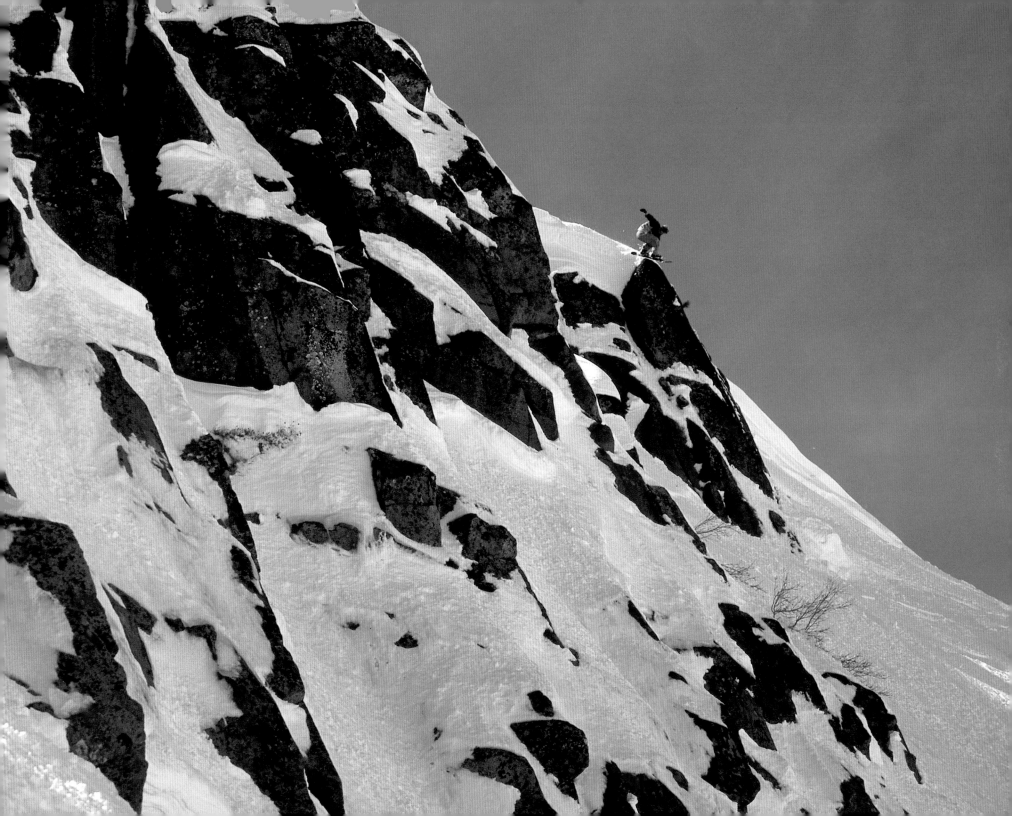

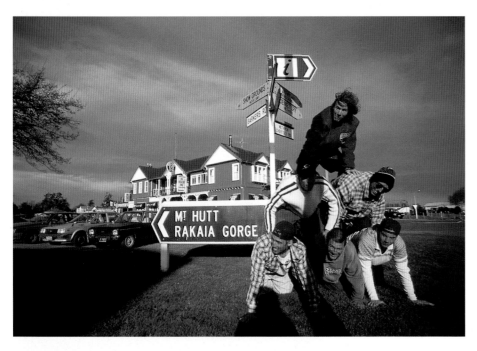

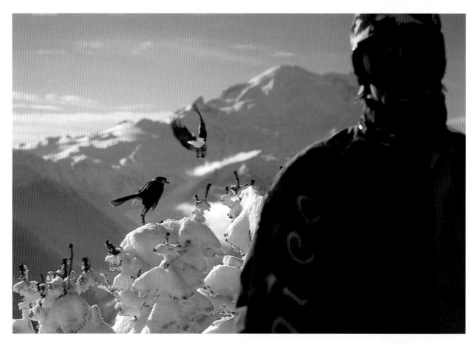

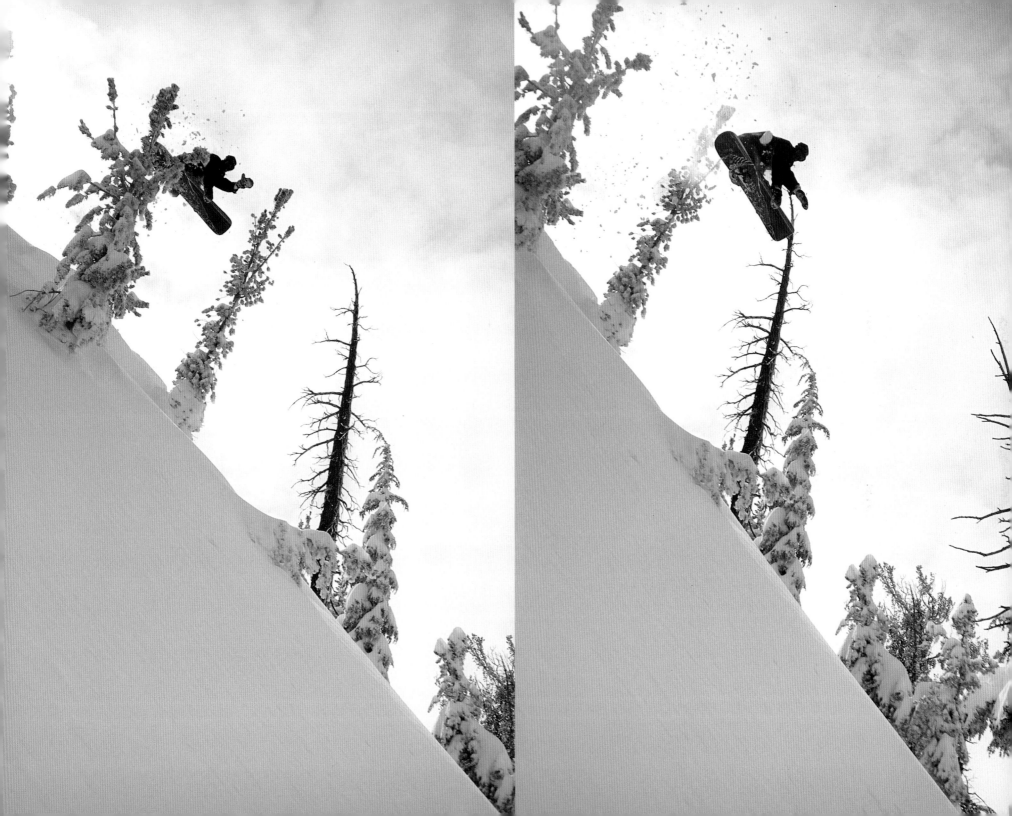

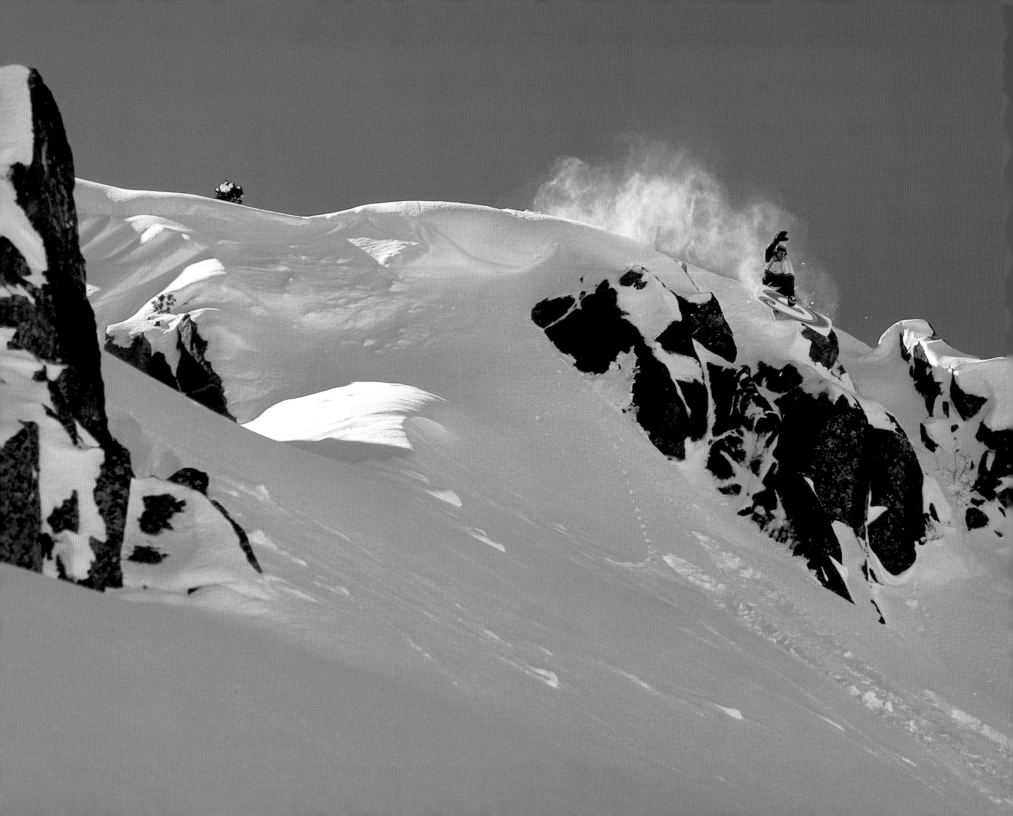

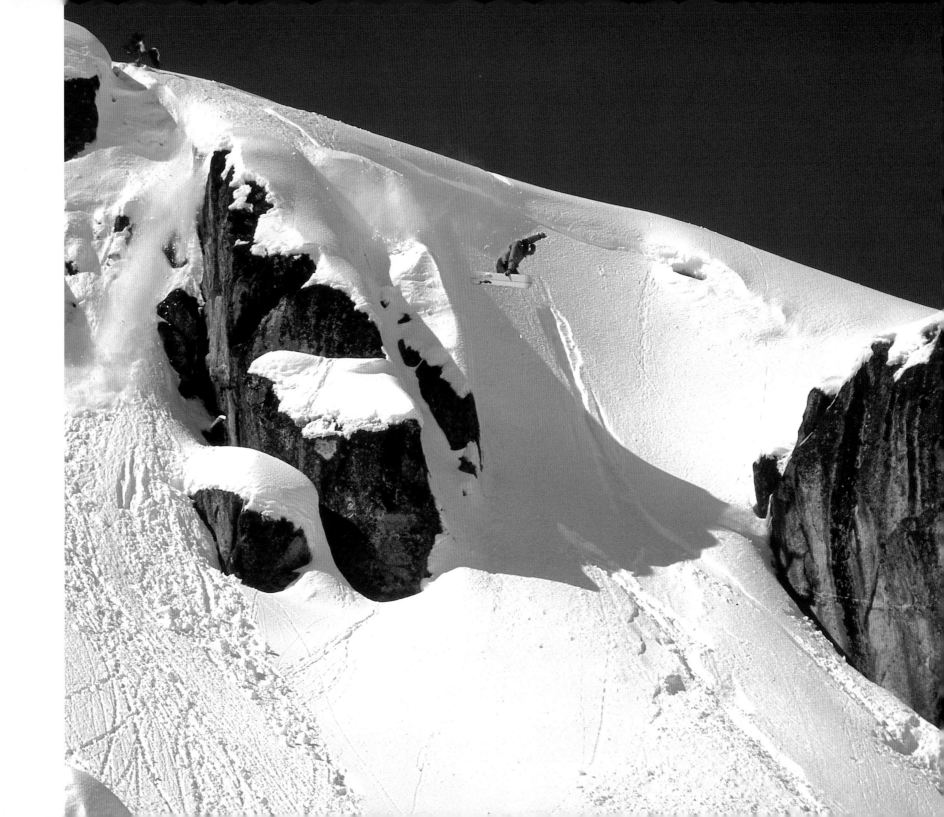

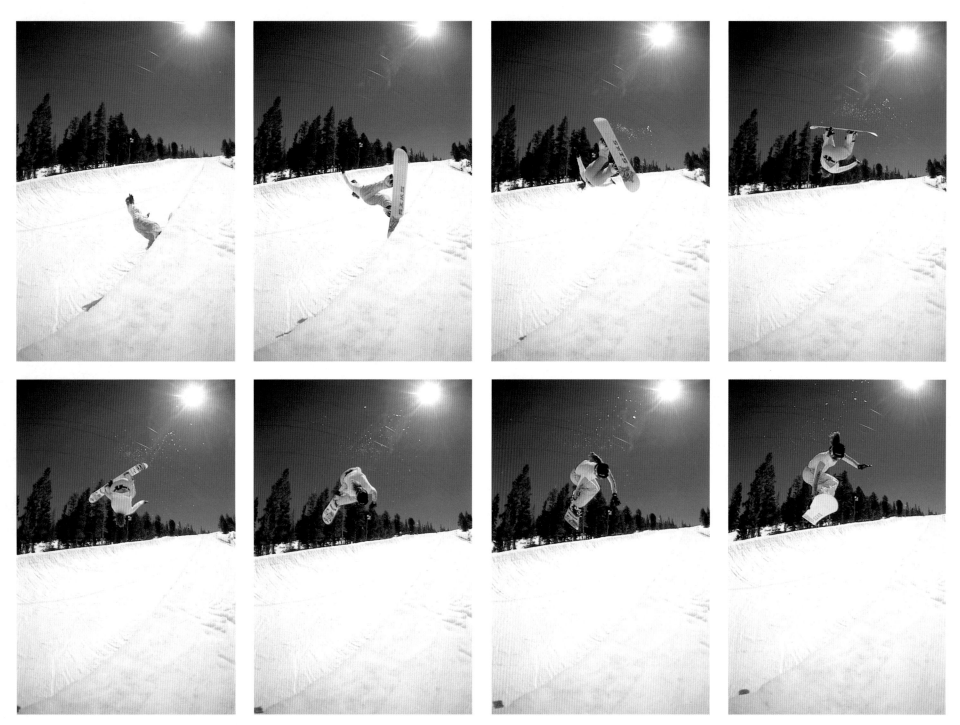

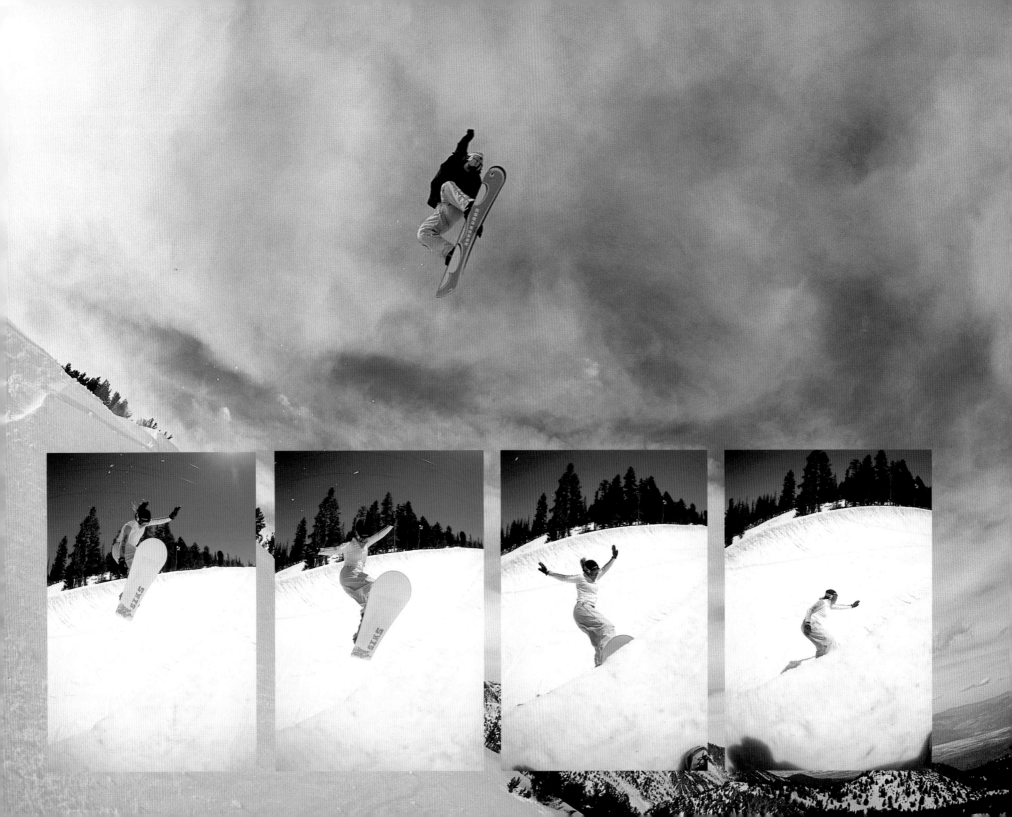

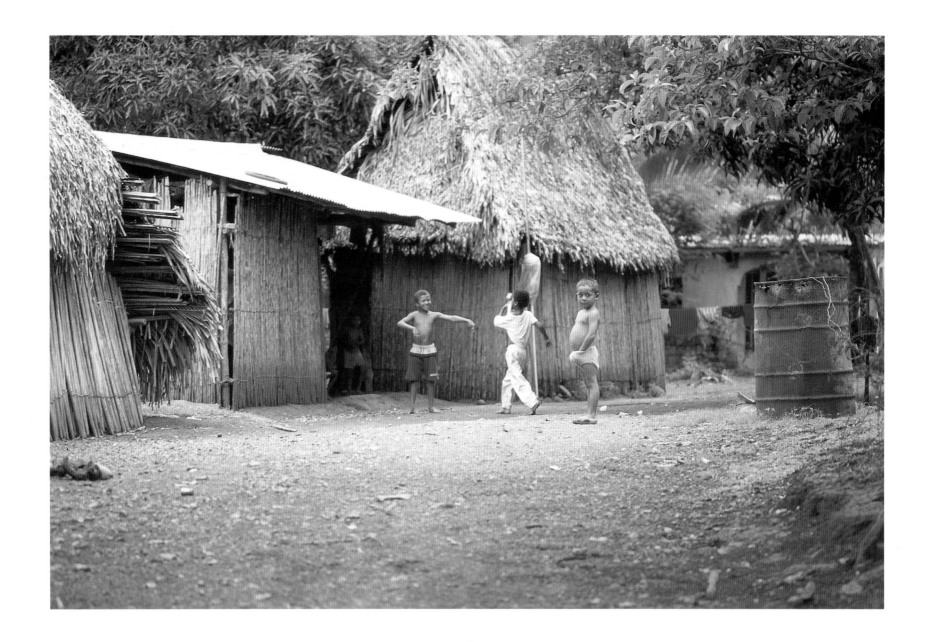

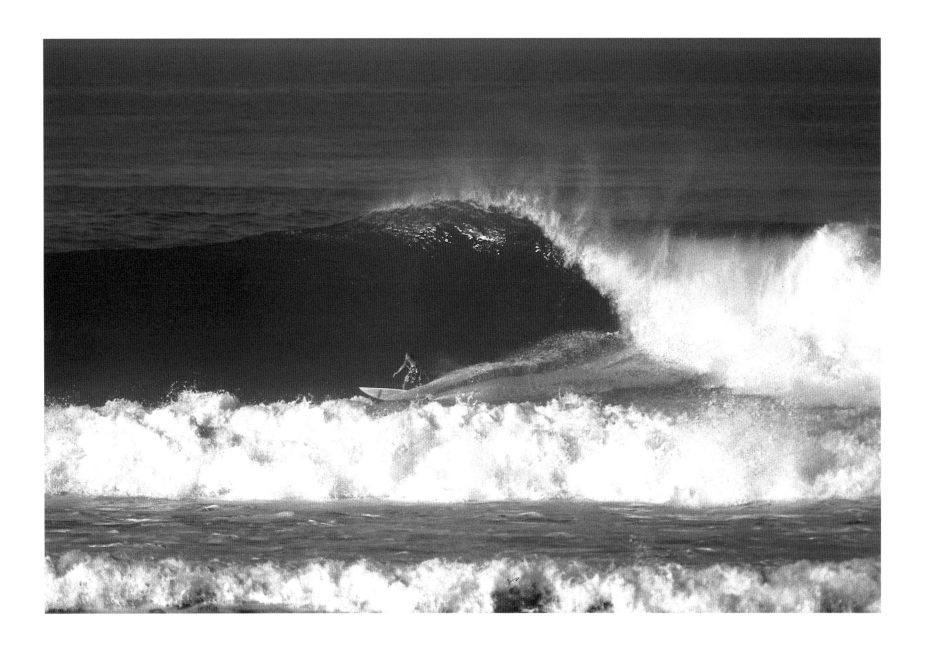

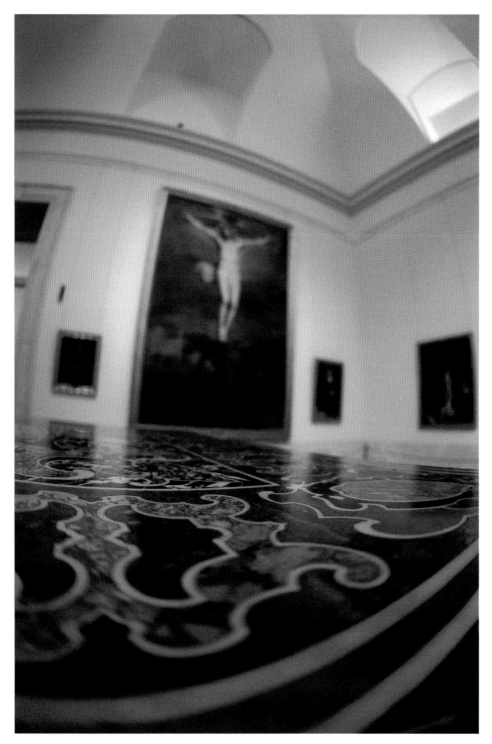

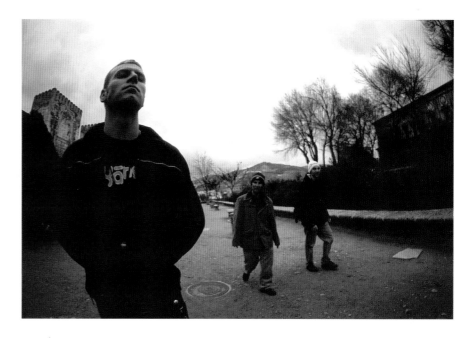

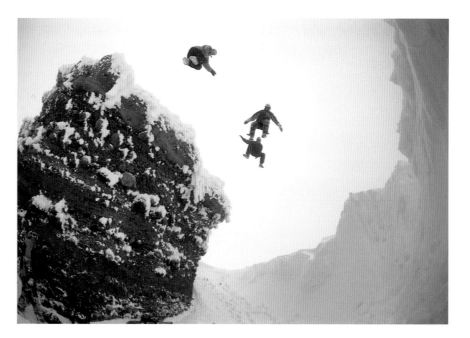

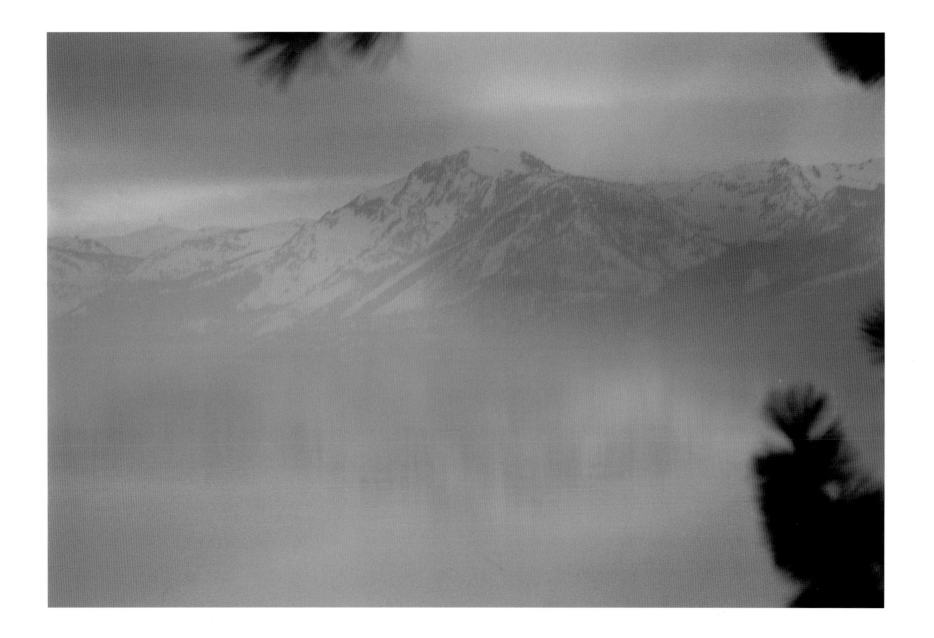

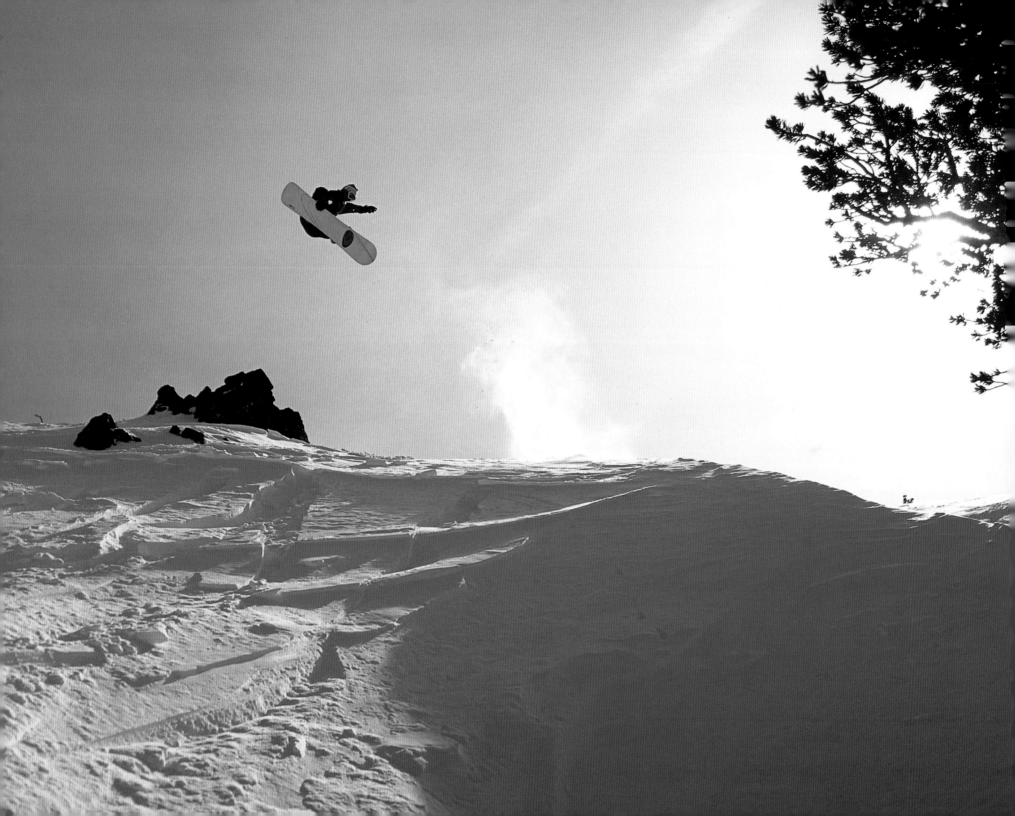

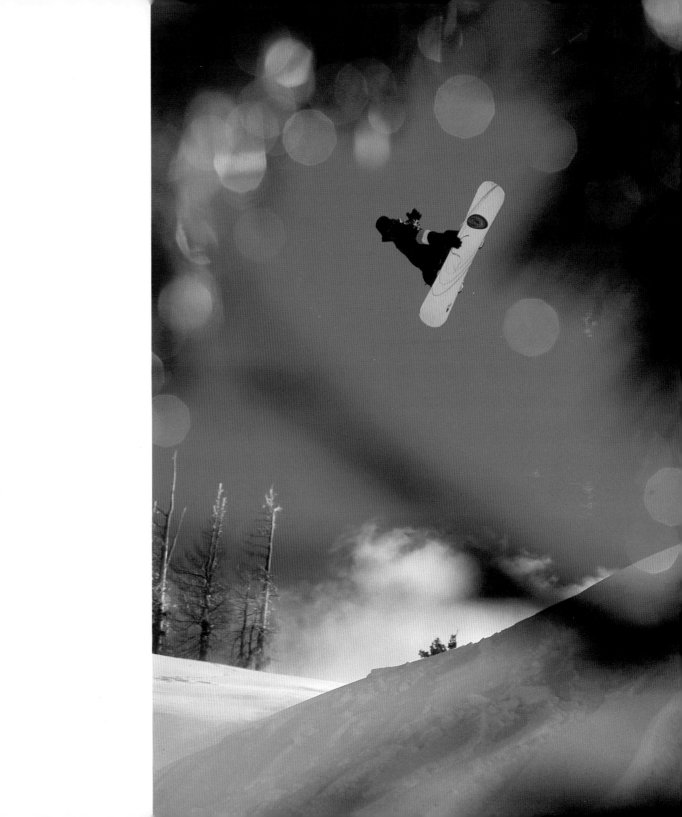

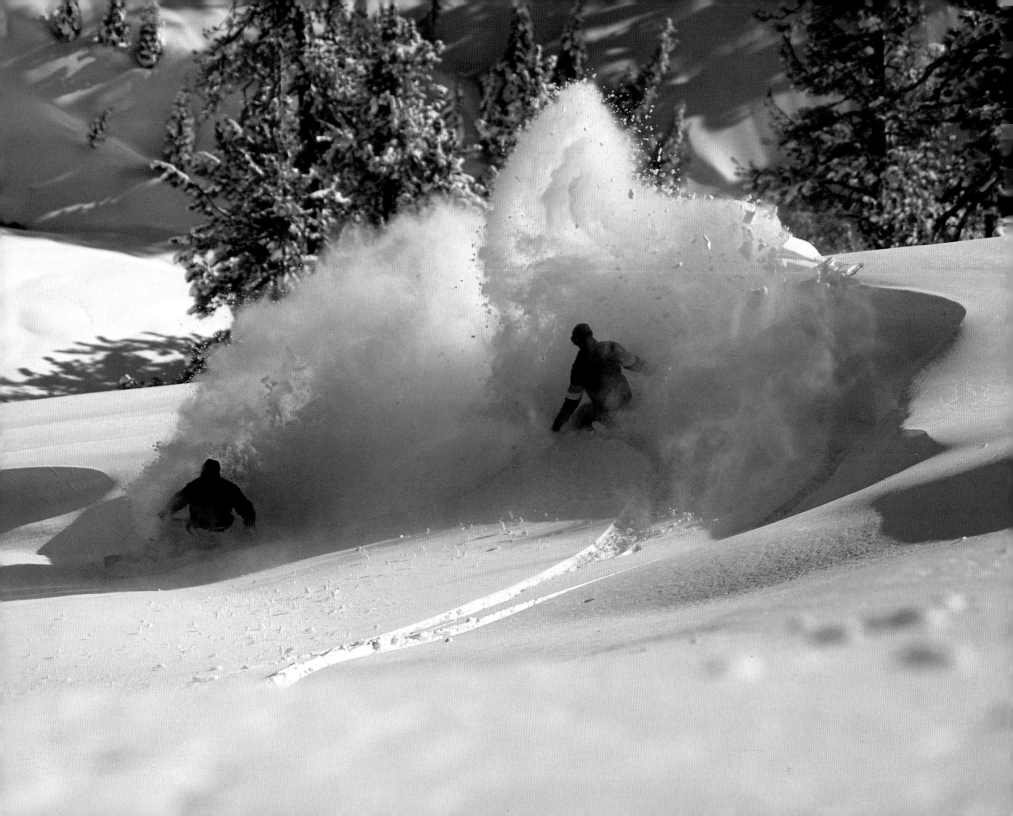

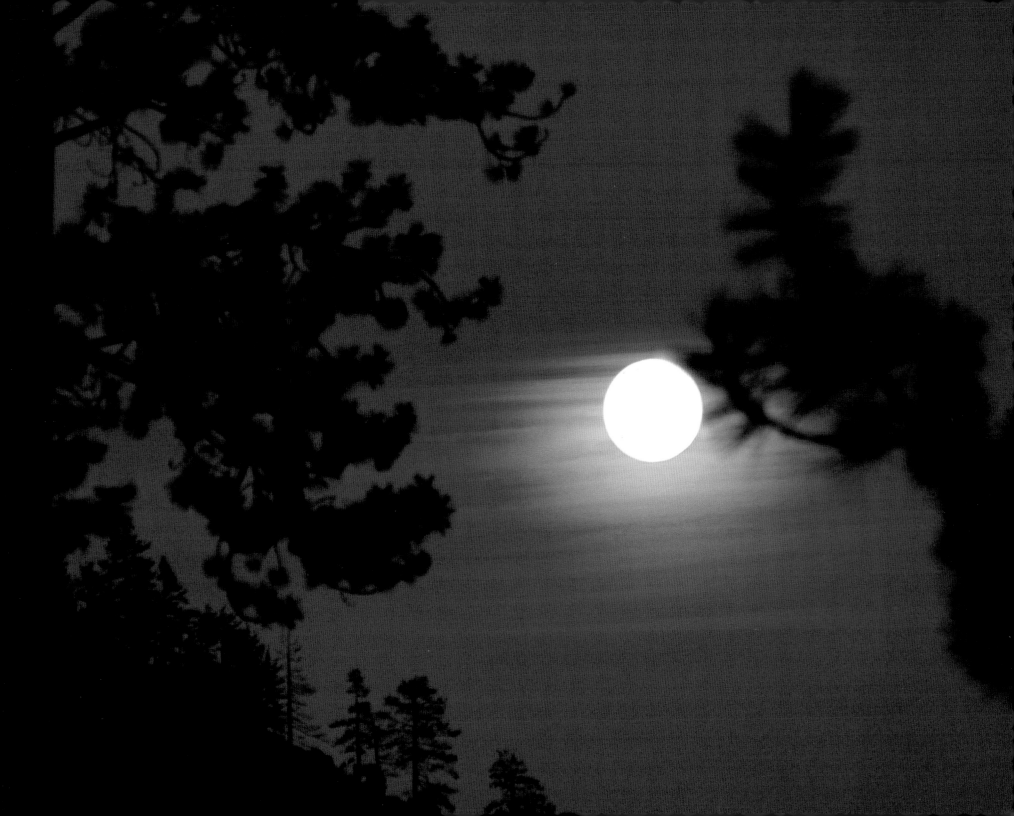

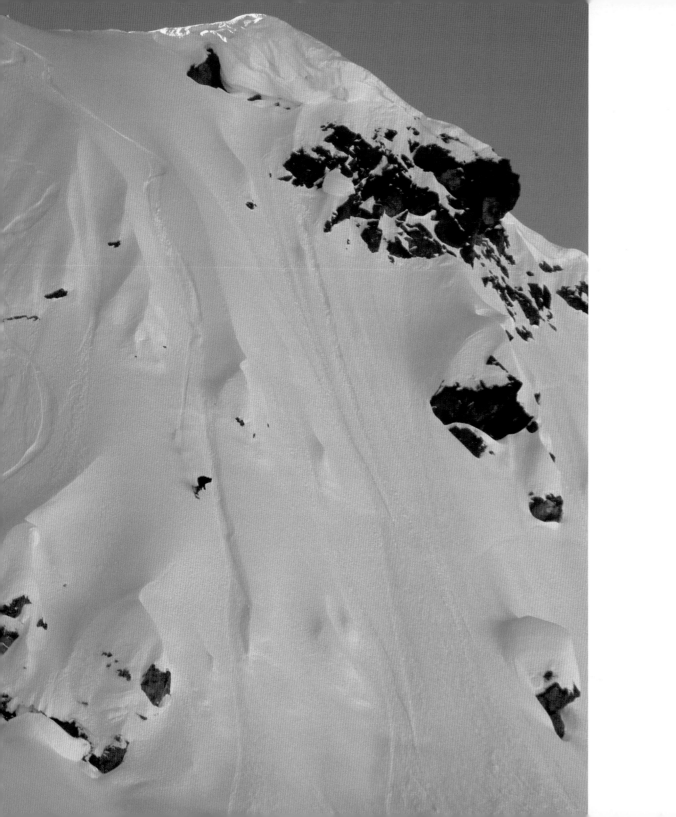

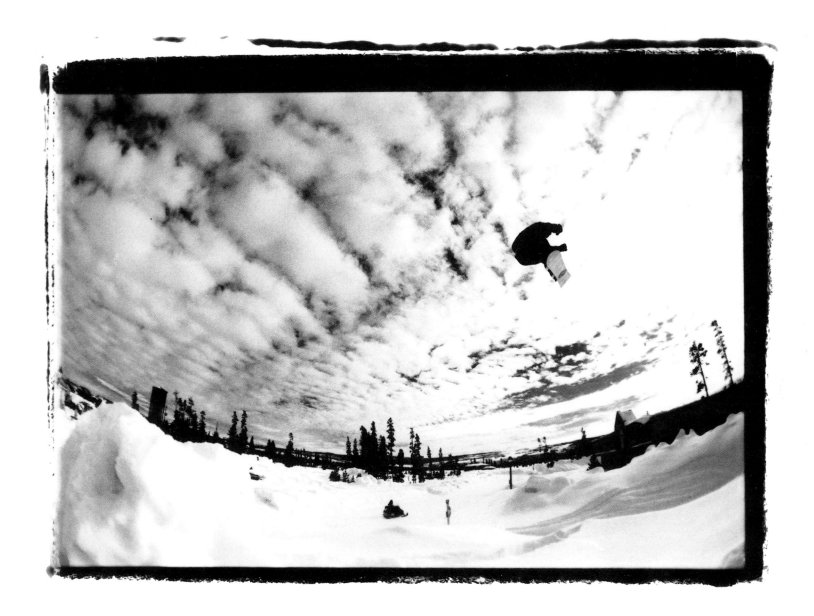

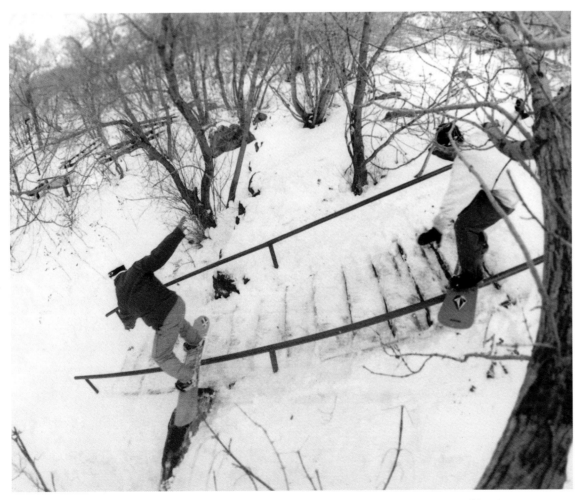

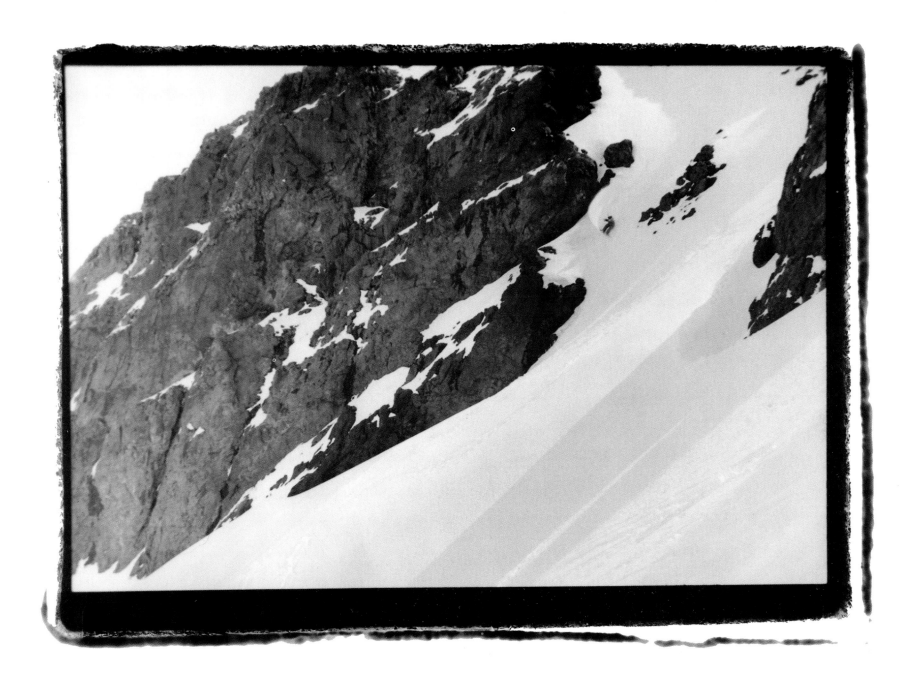

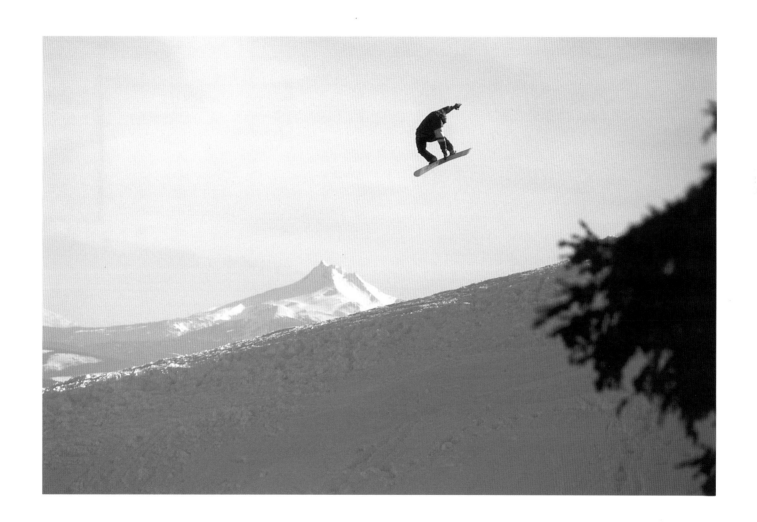

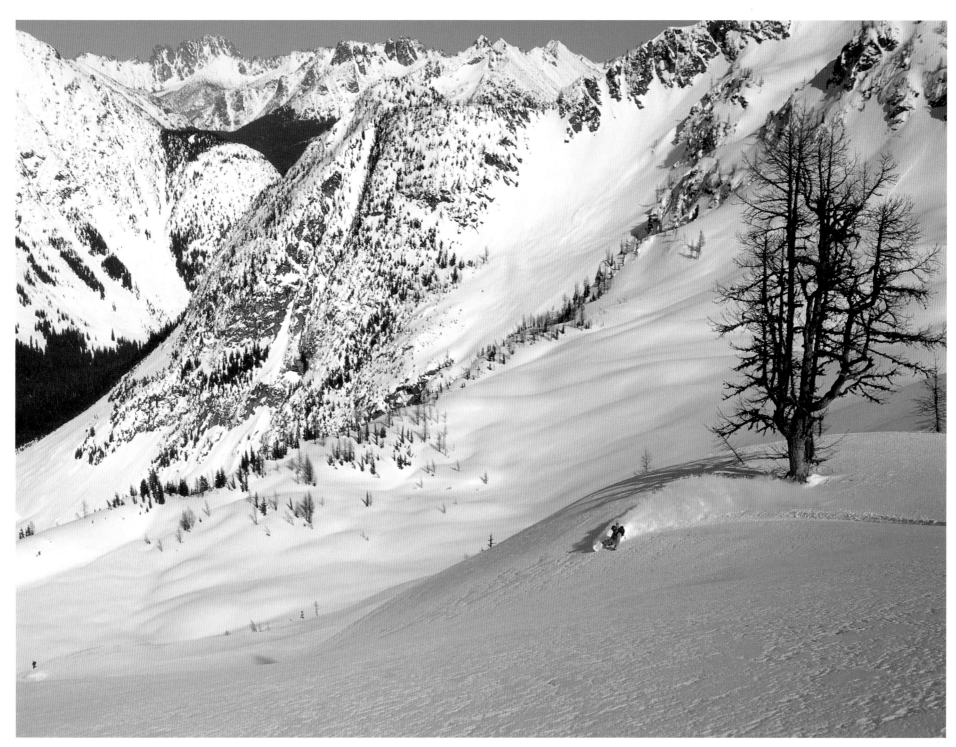

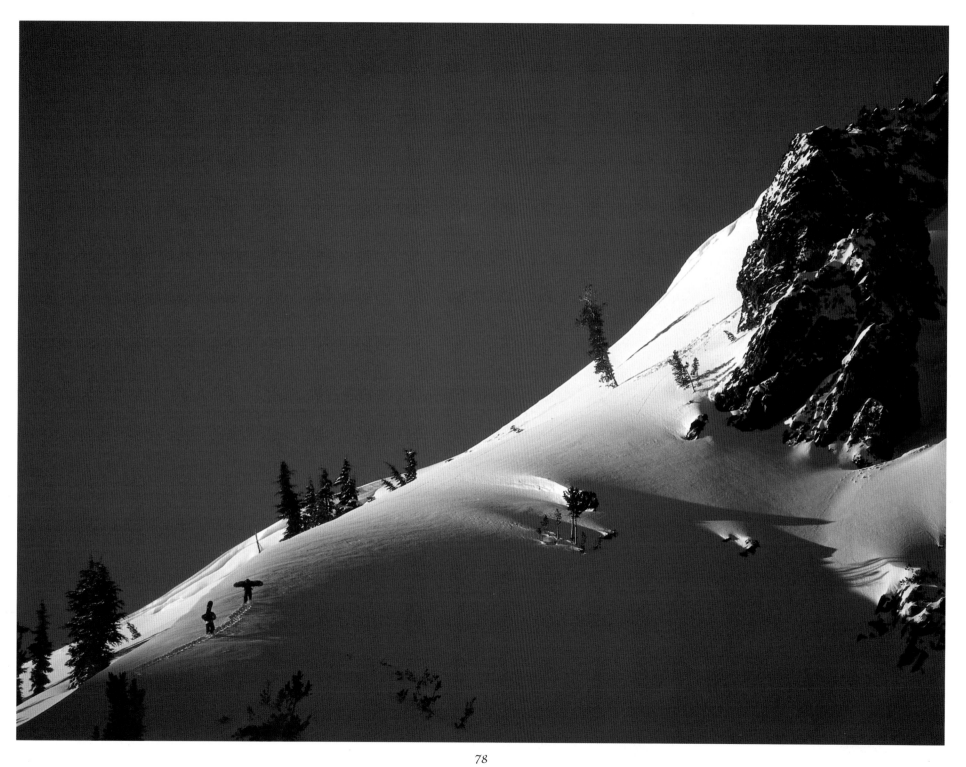

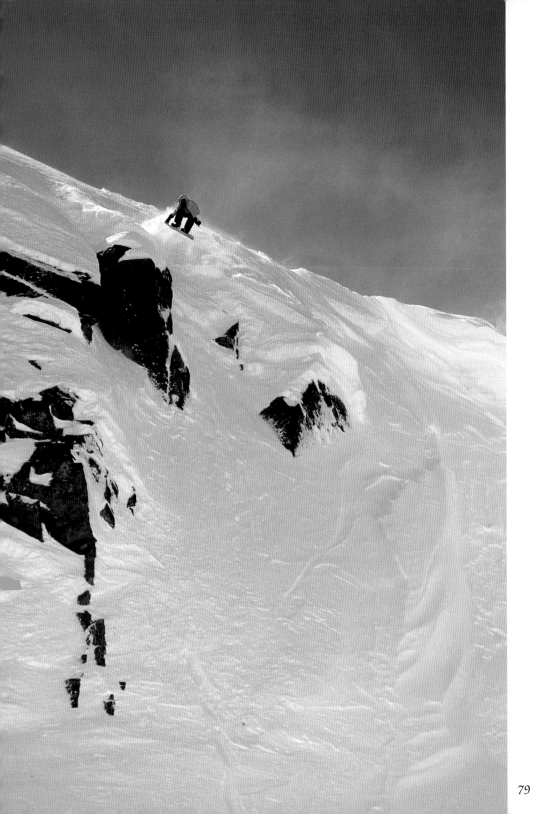

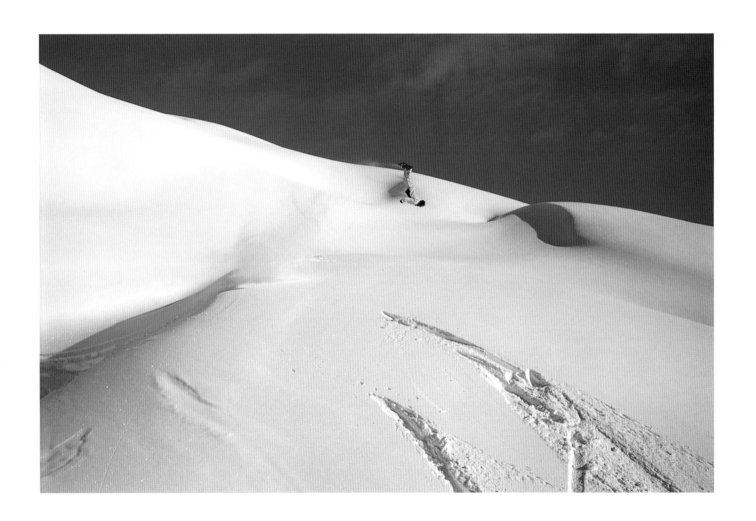

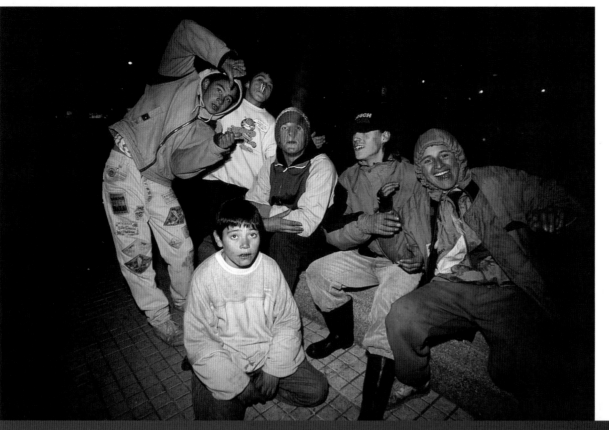

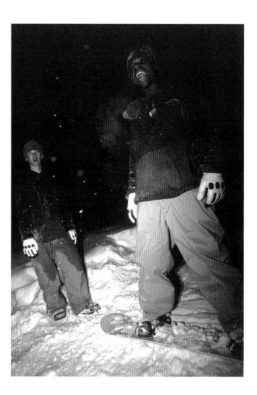

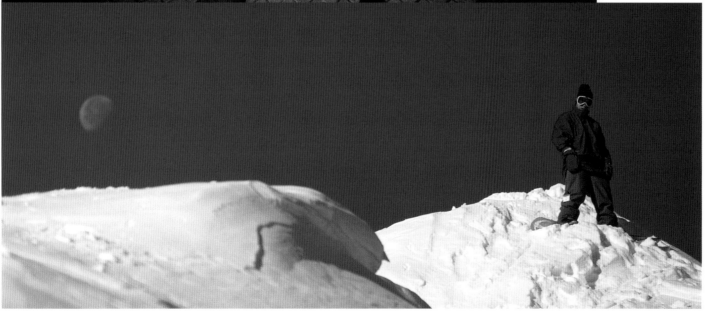

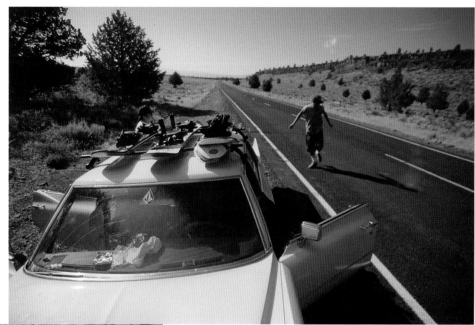

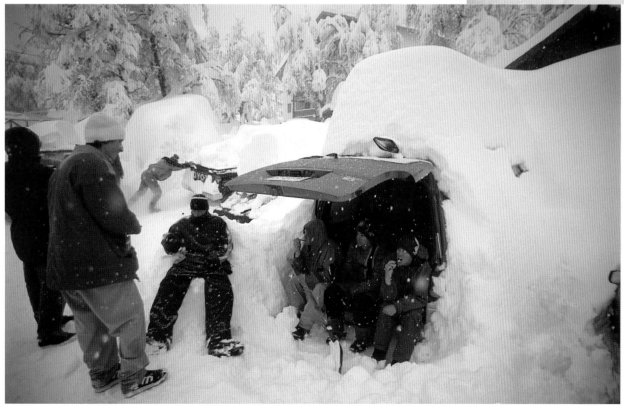

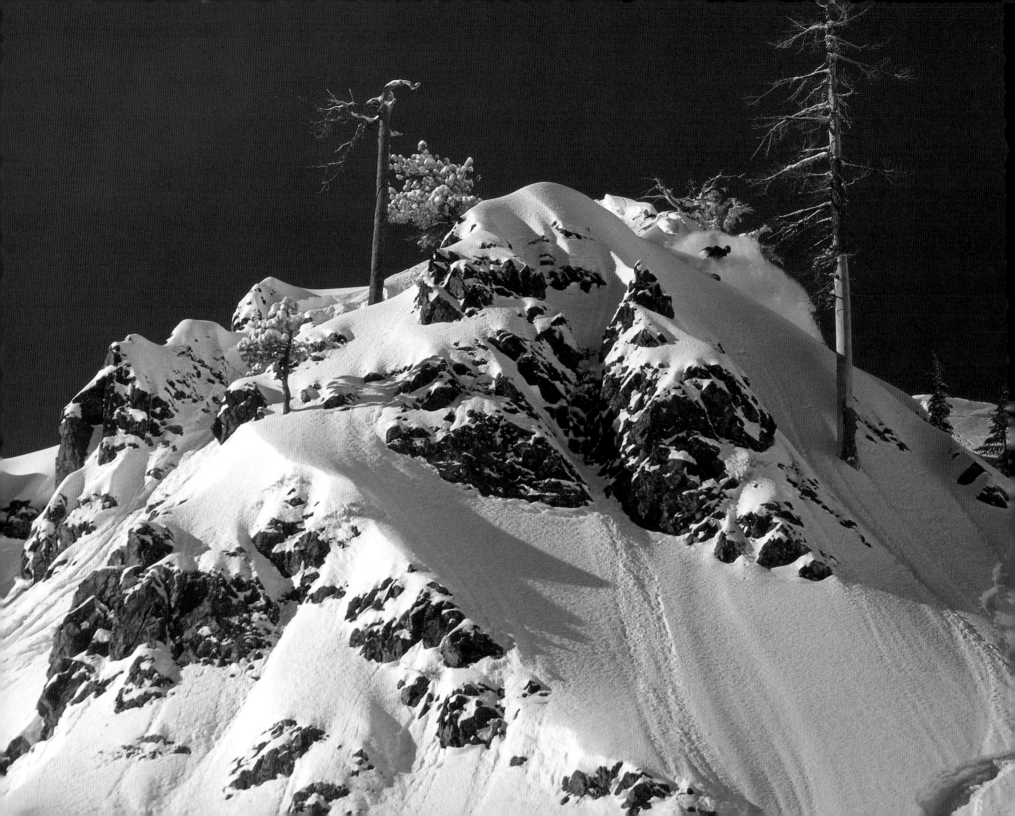

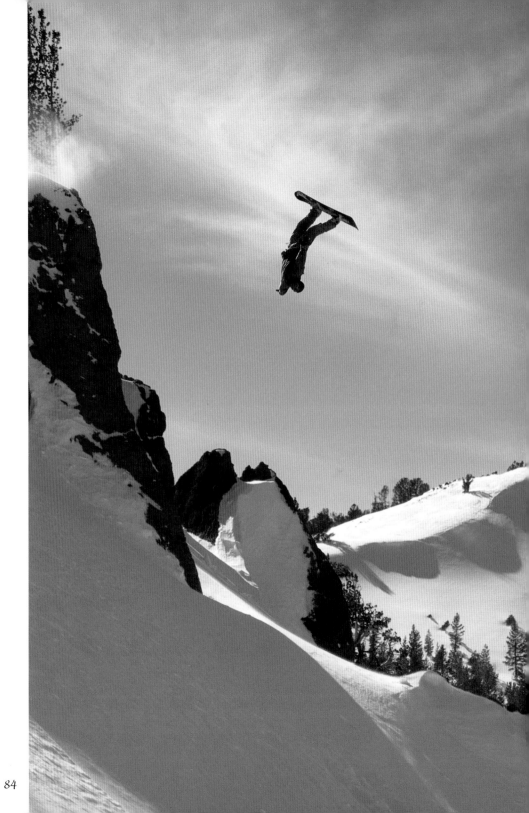

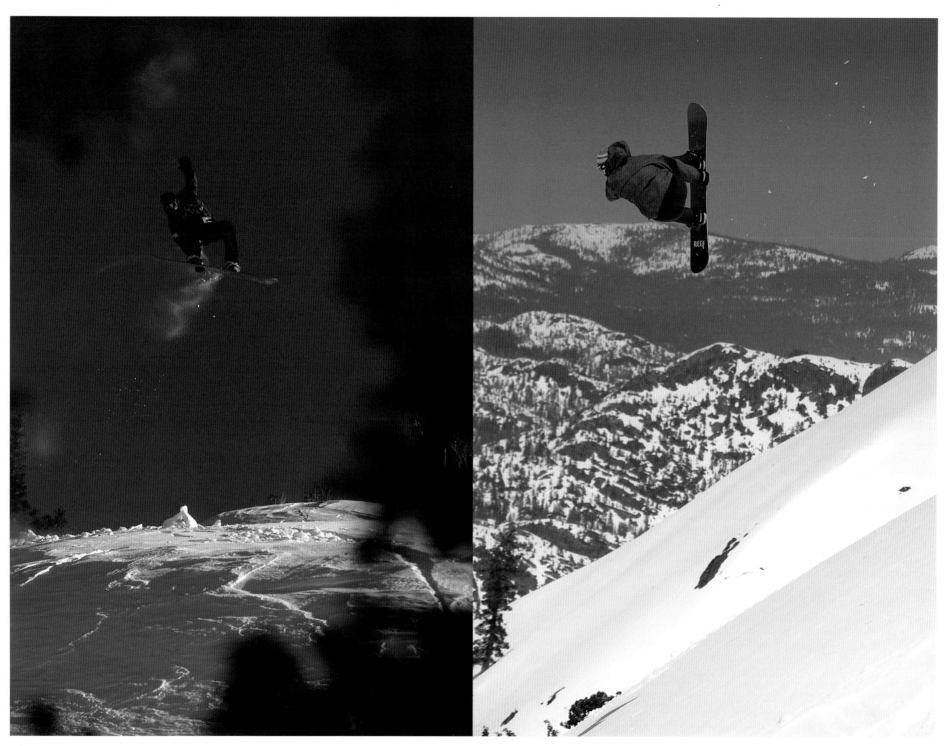

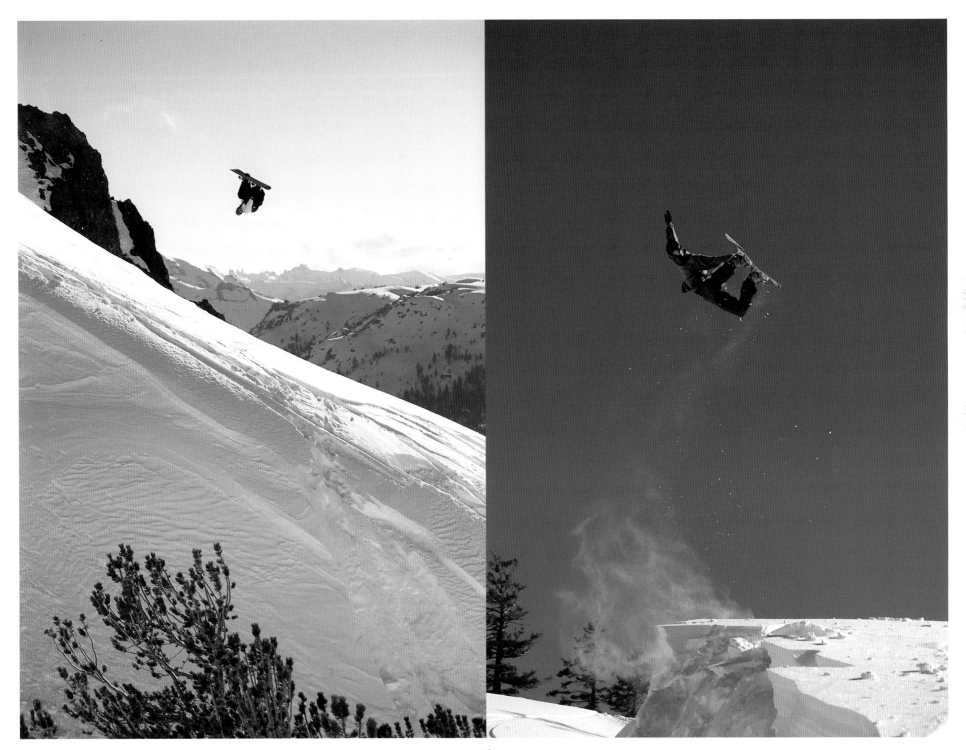

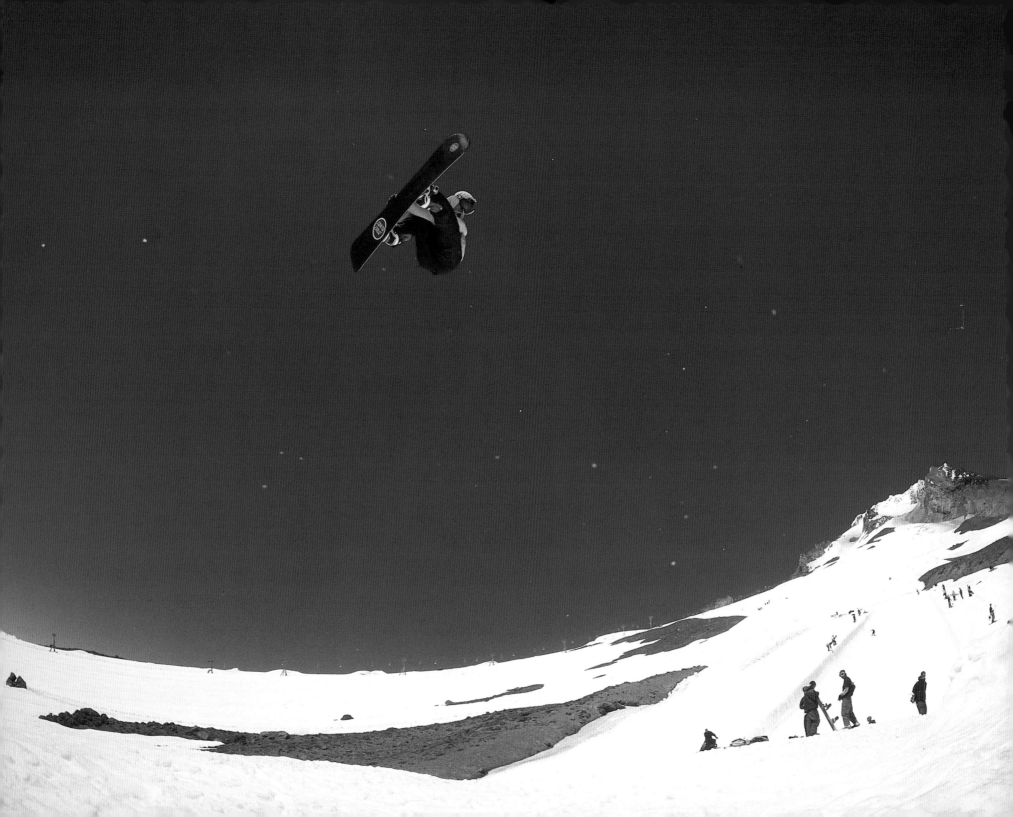

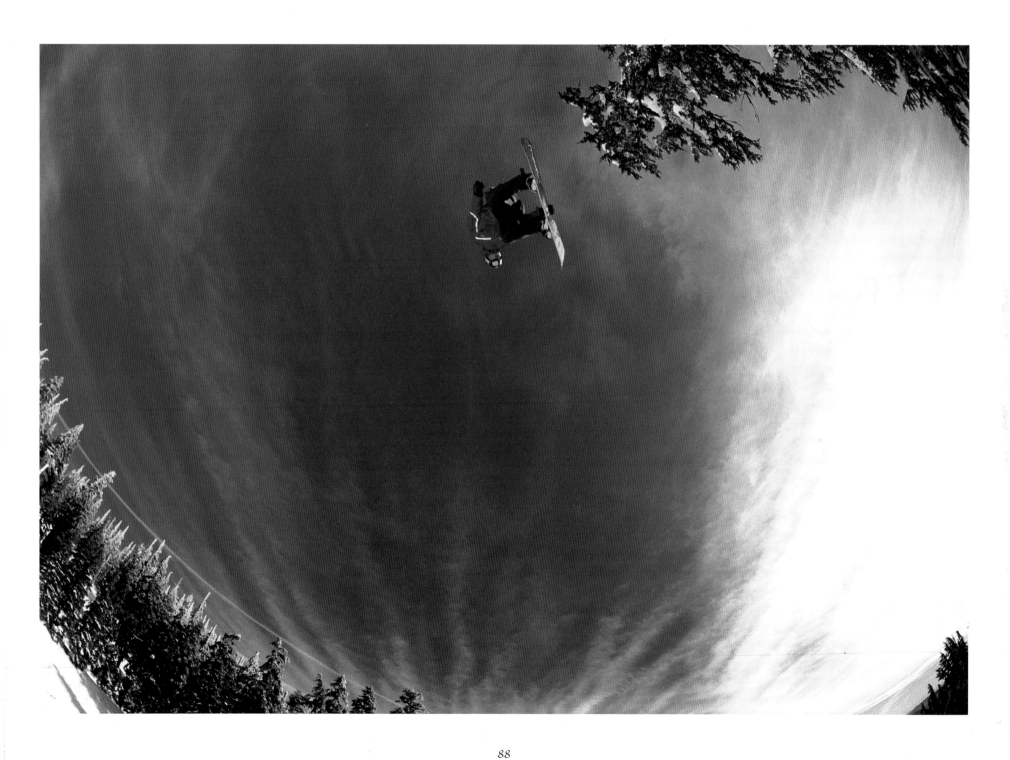

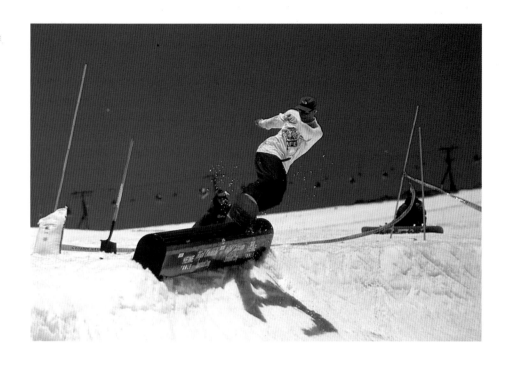

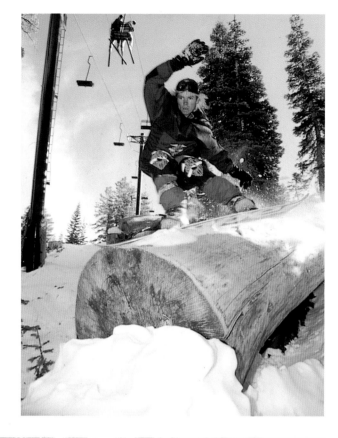

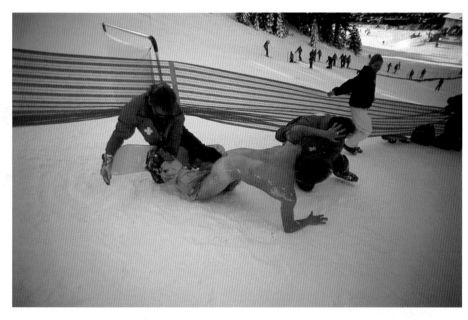

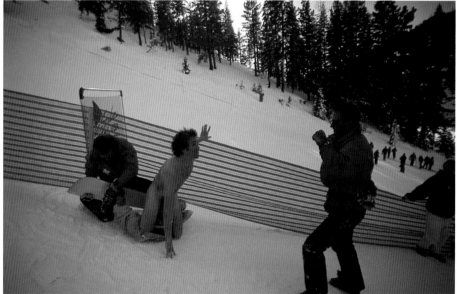

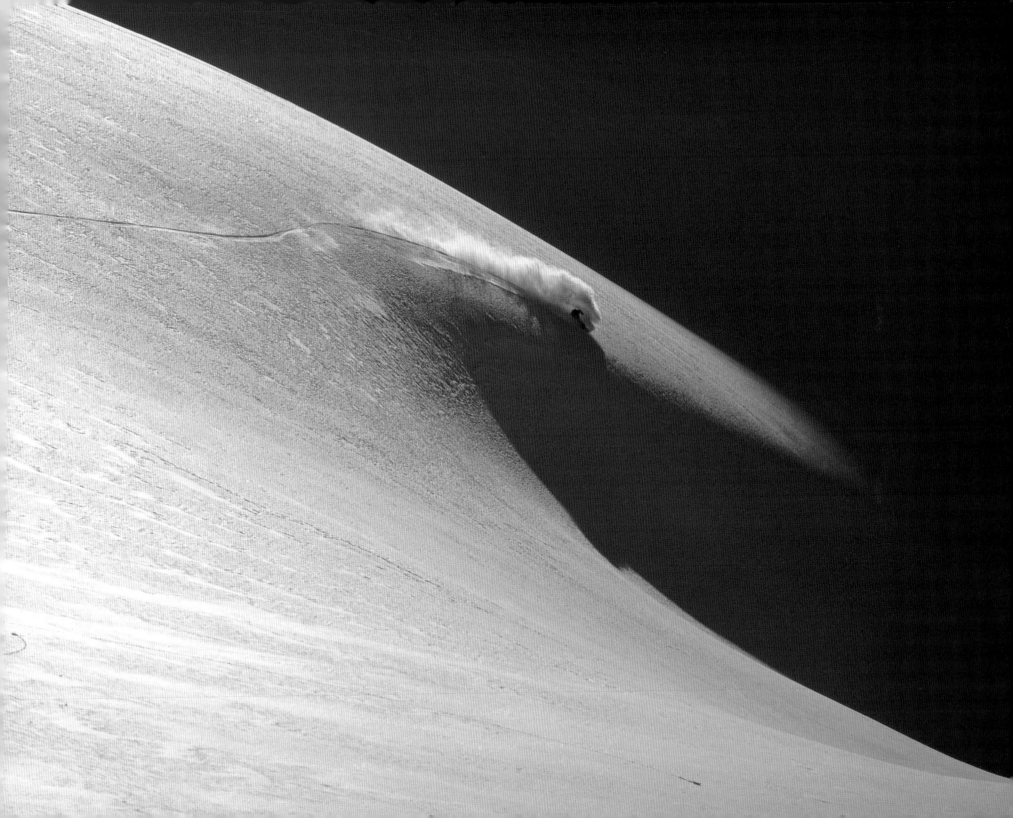

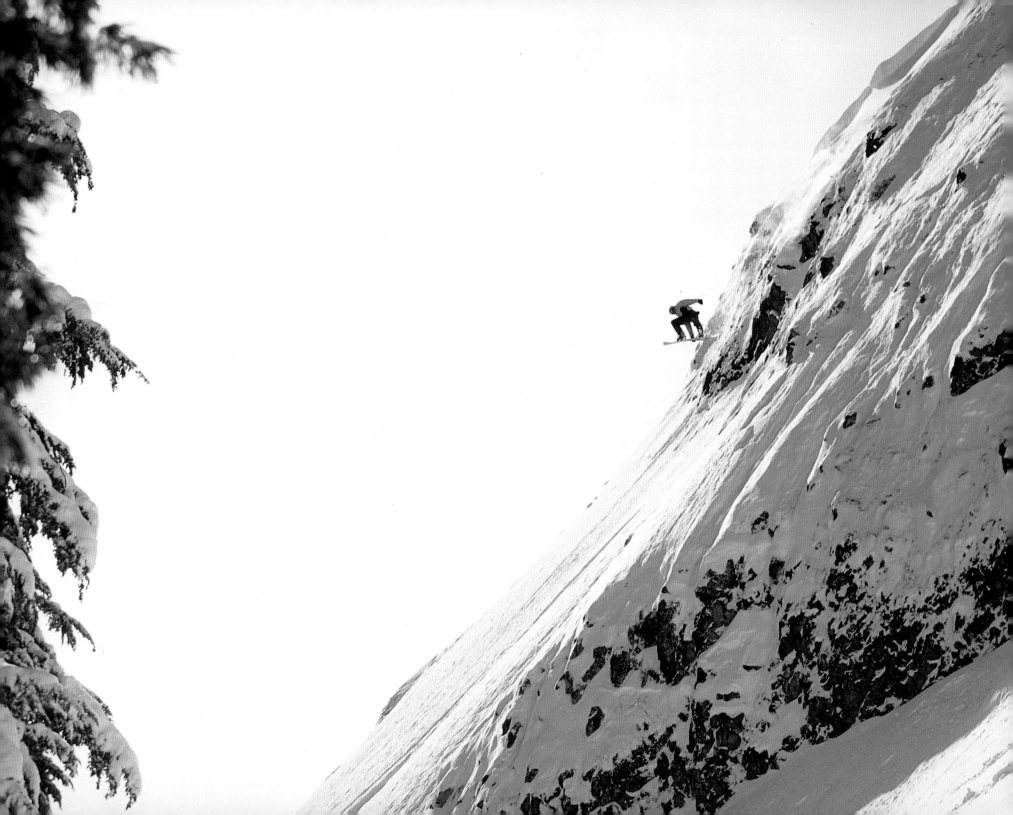

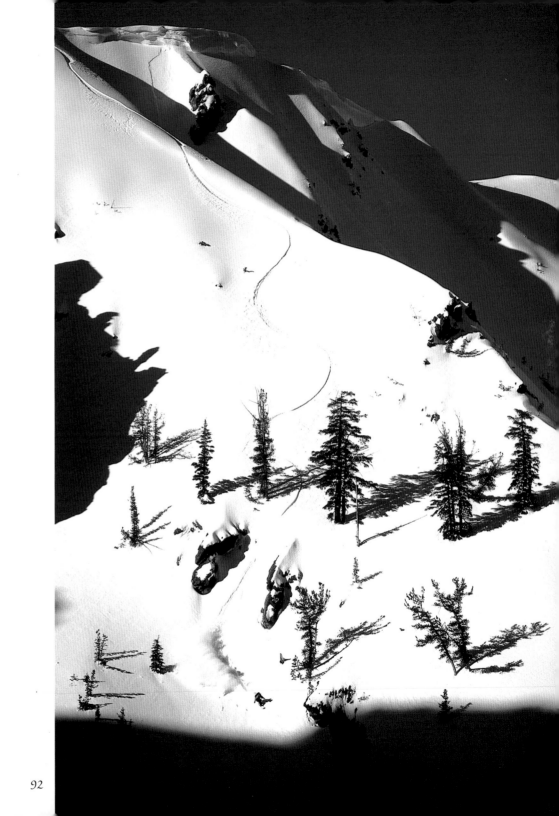

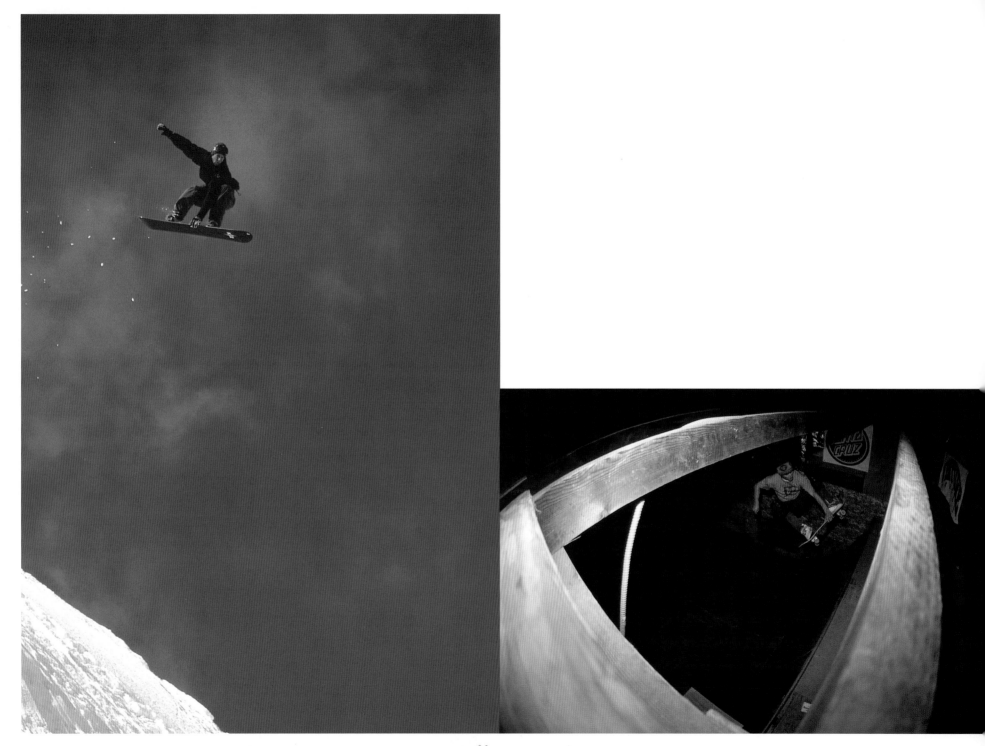

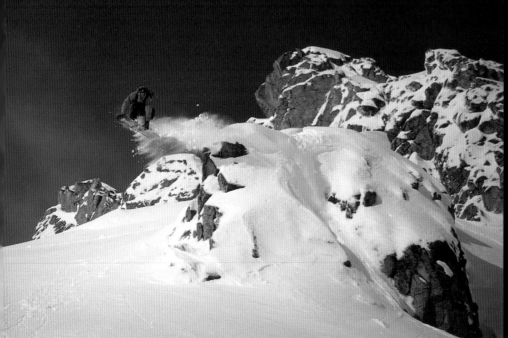

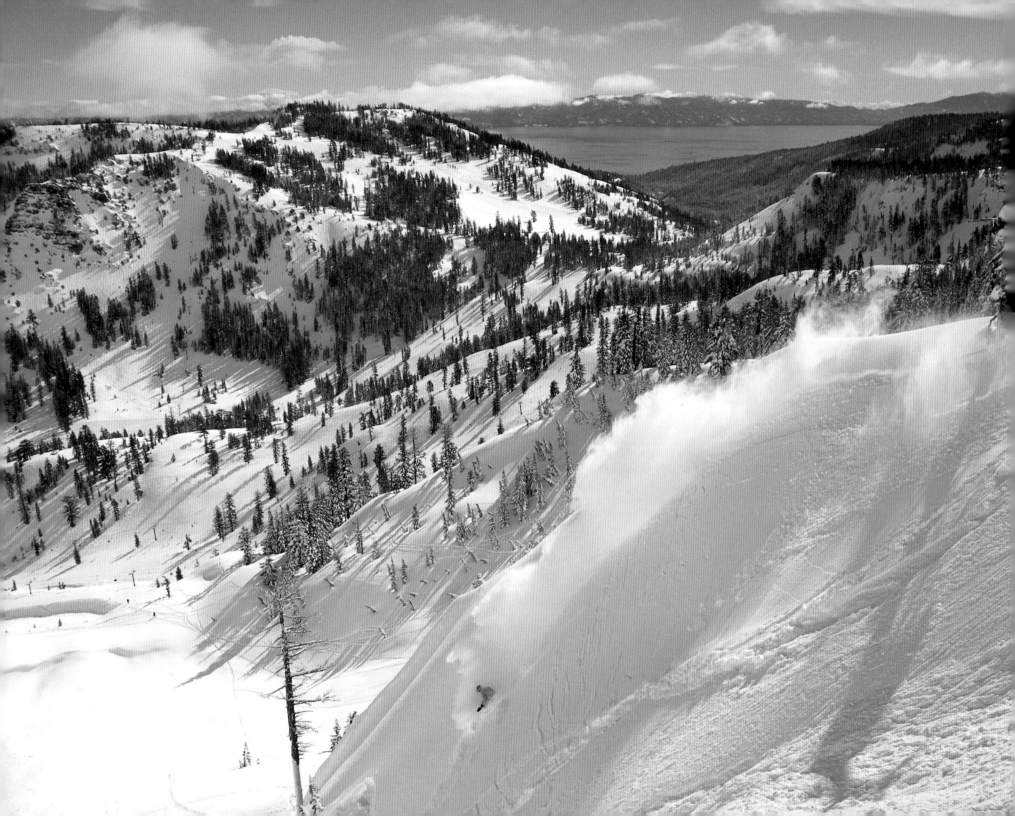

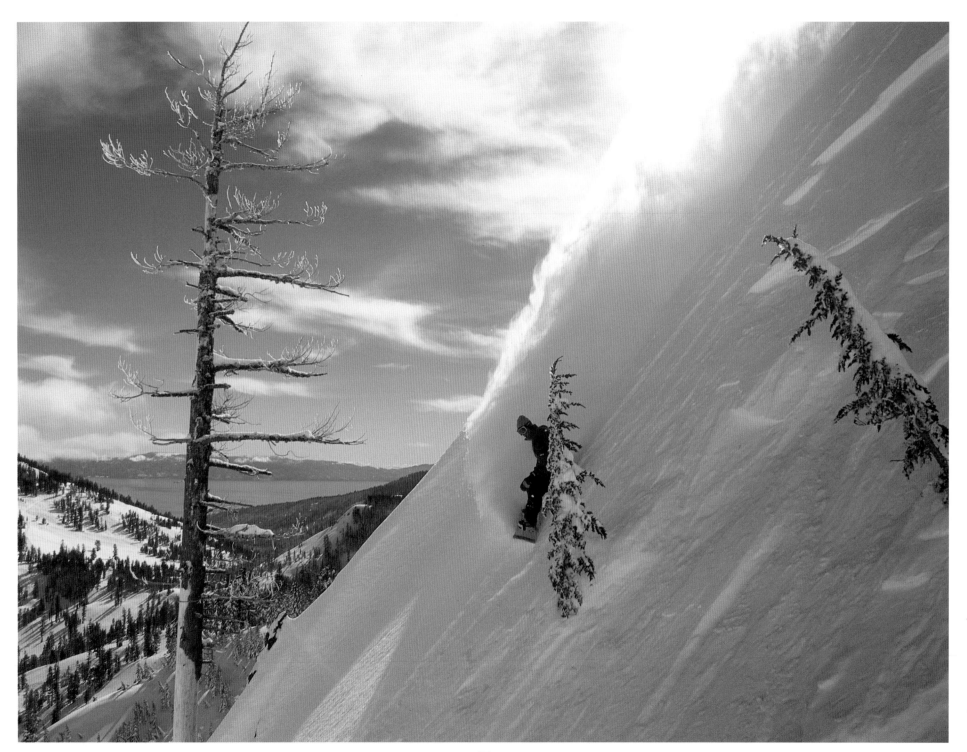

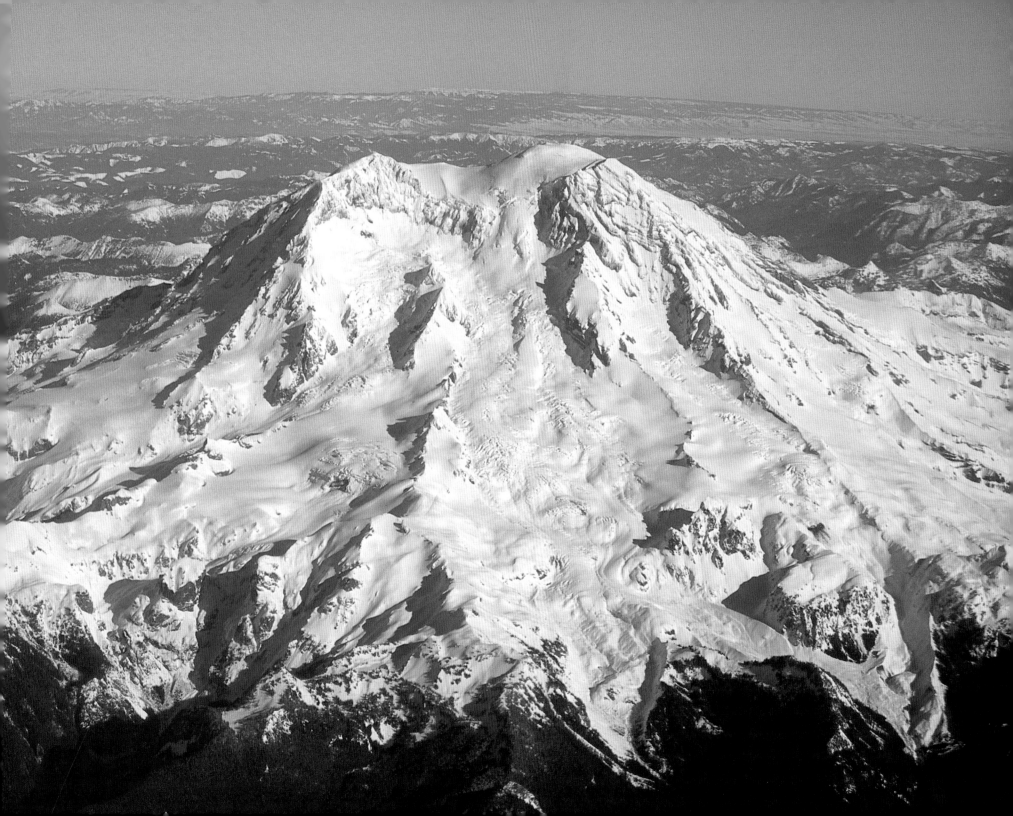

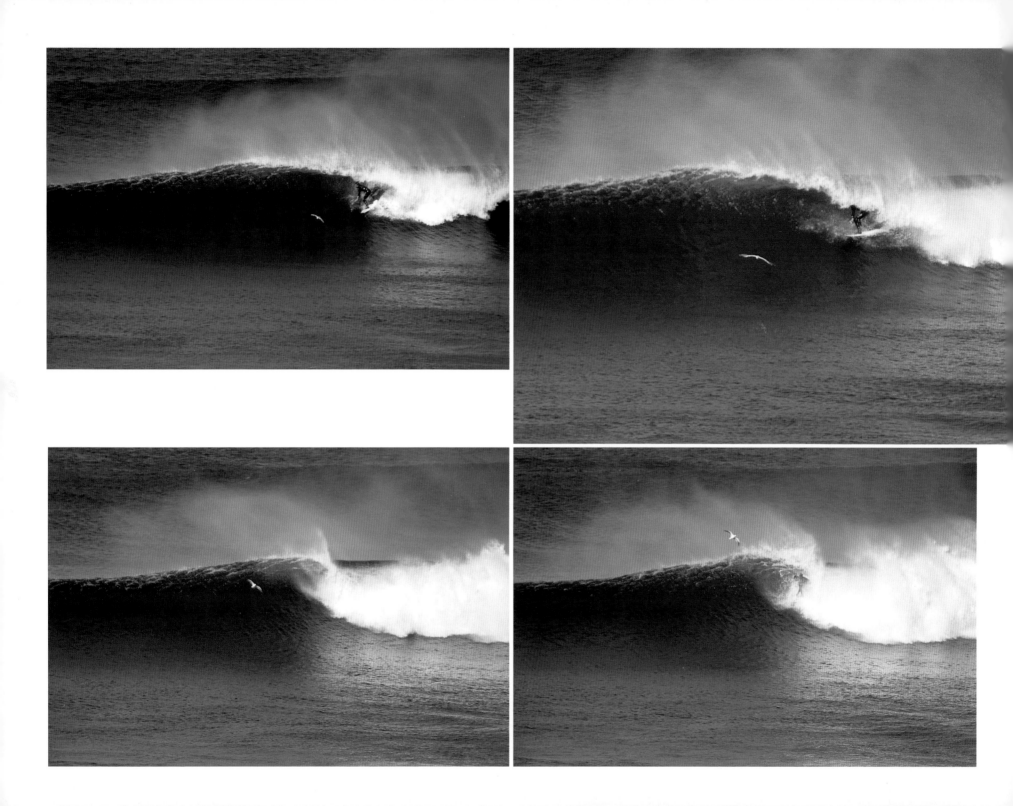

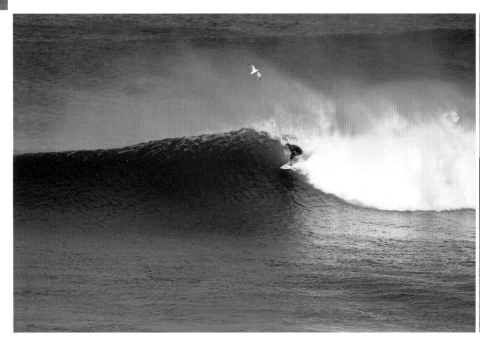
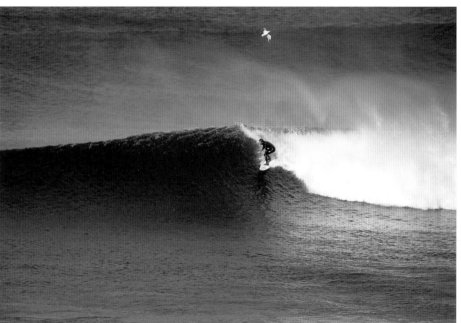

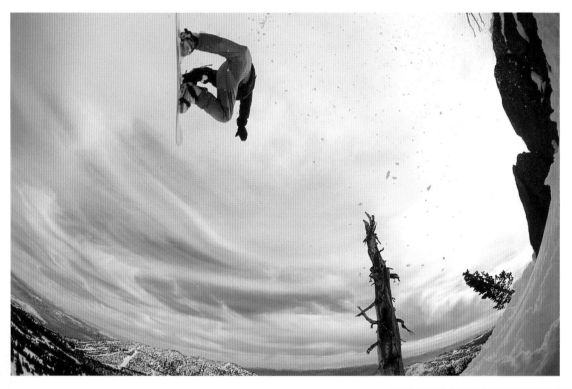

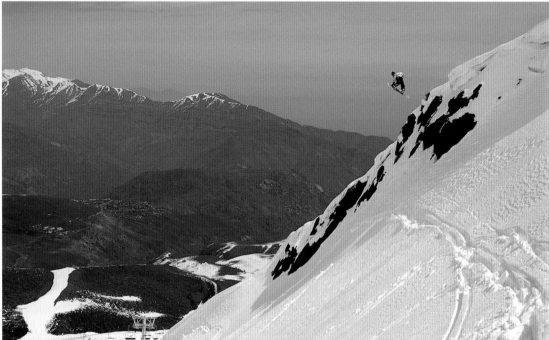

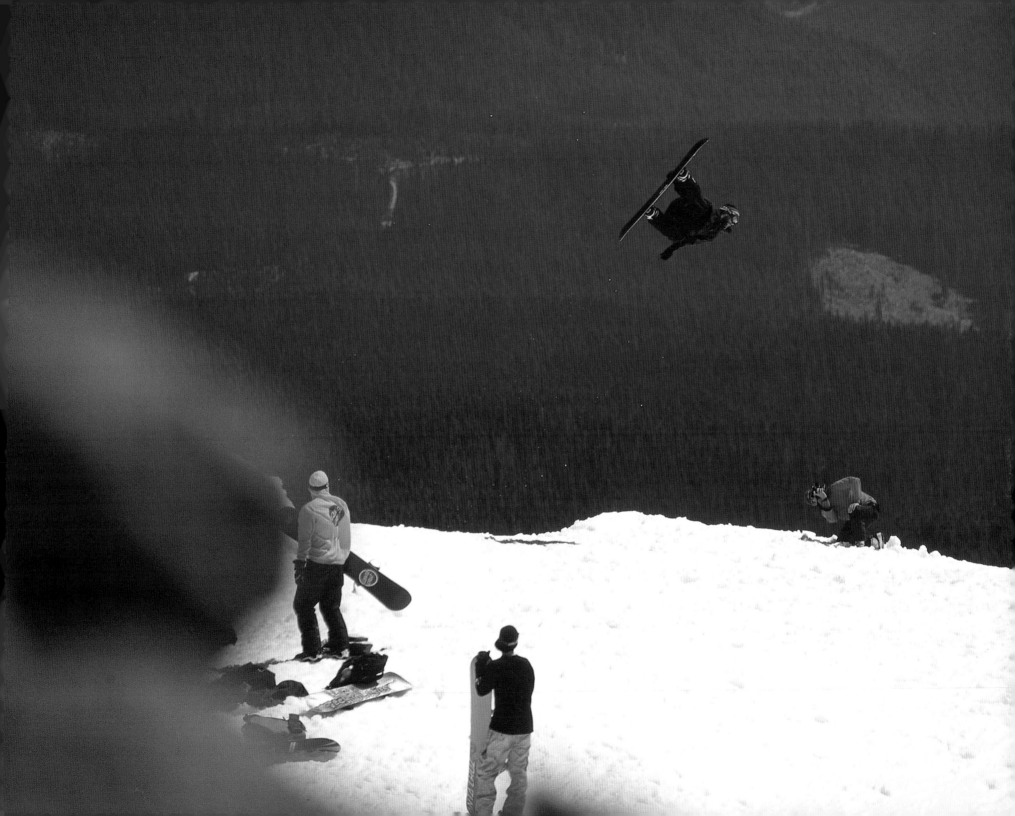

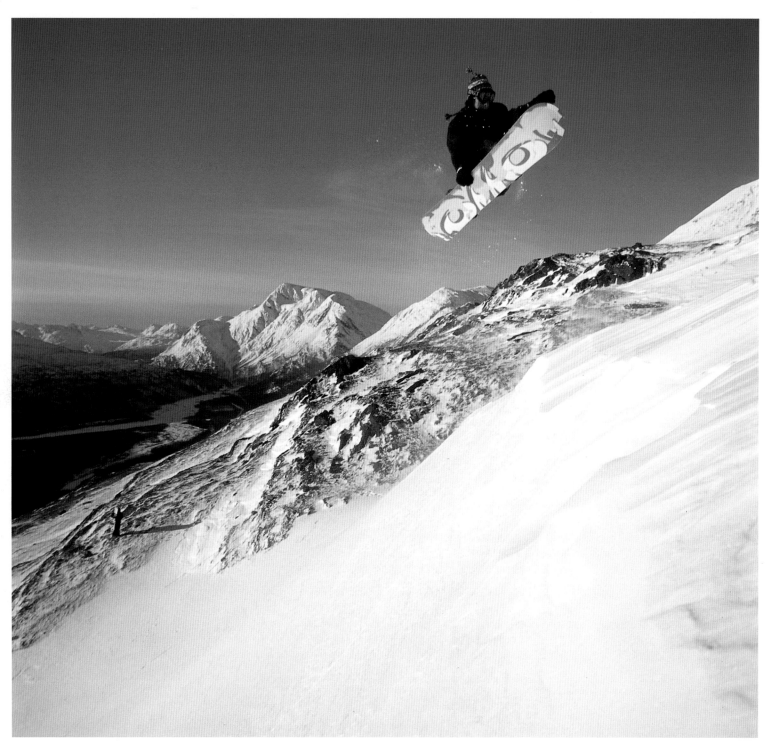

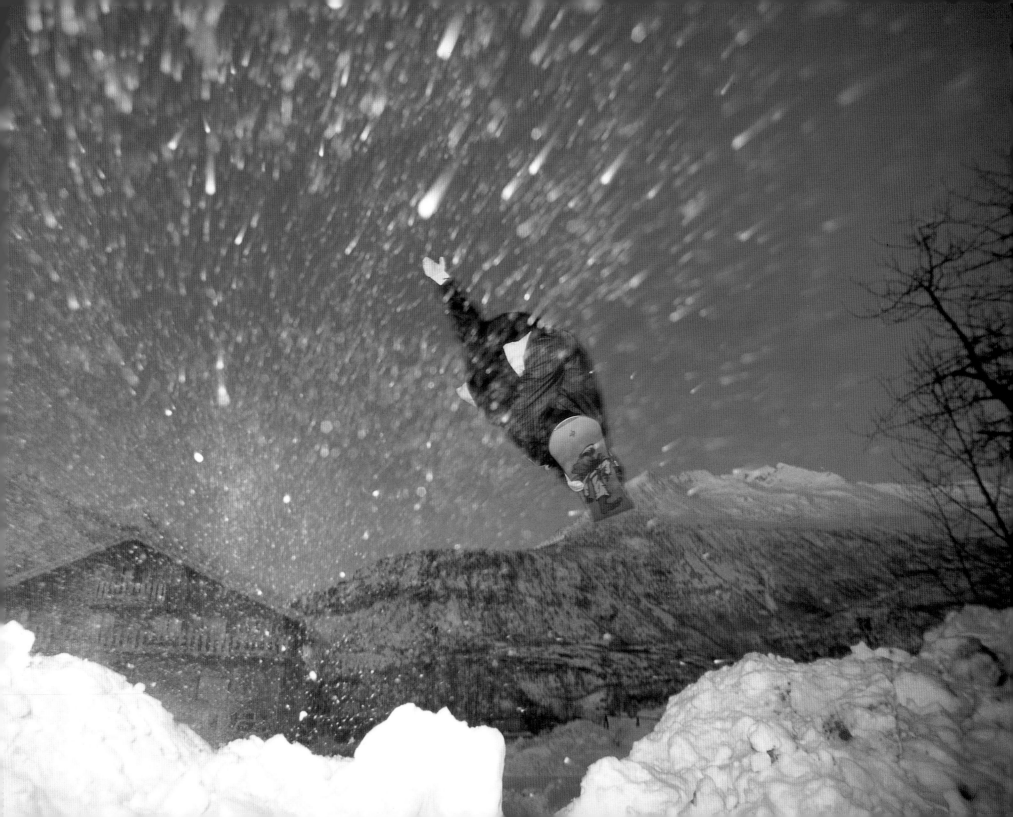

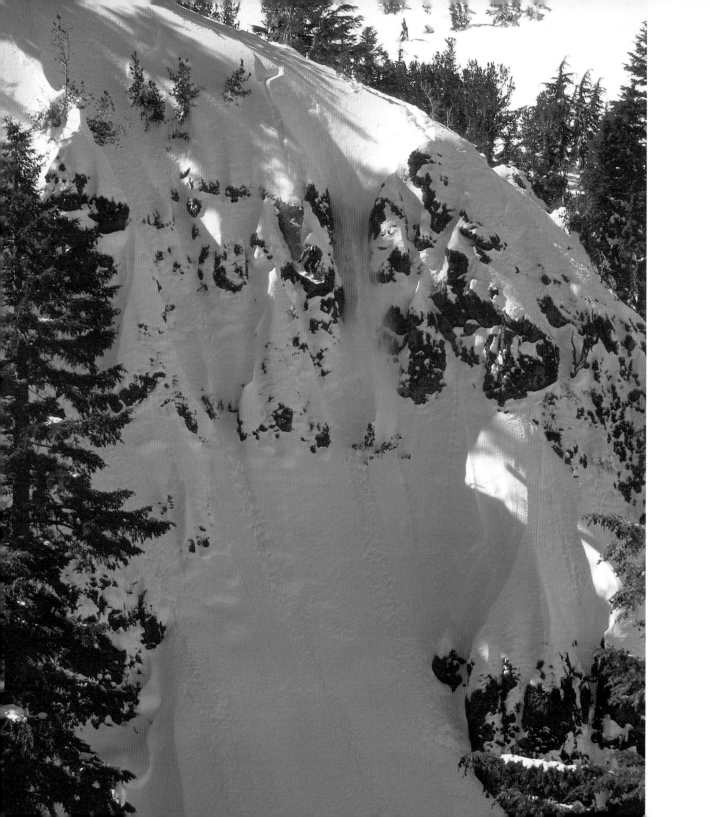

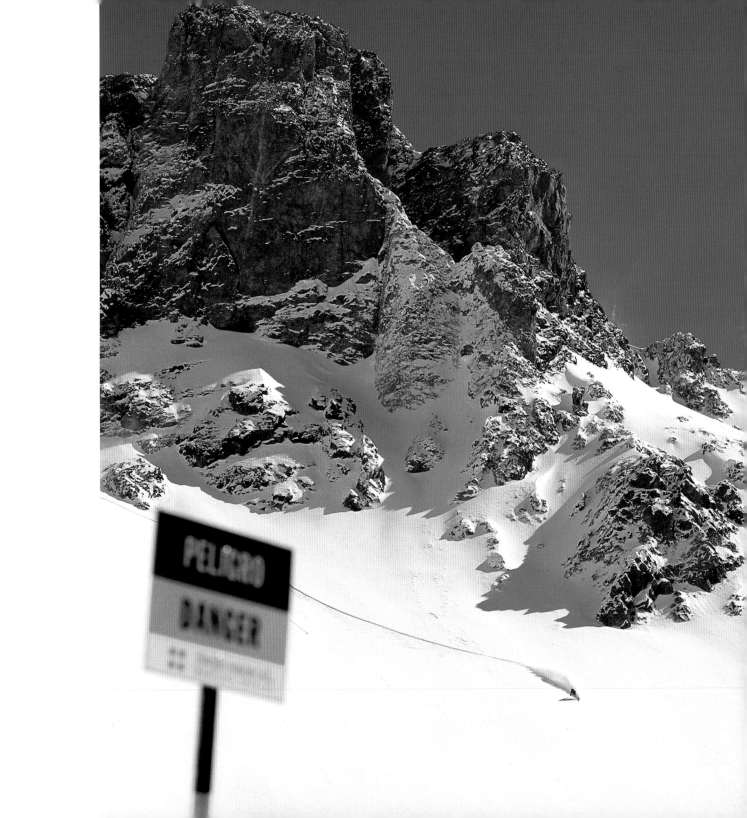

index

Page 57-top left- Peter Line, Todd Schlosser, Mike McEntire, Dave Lee, Joey McGuire, and Jamie Lynn in Methven, New Zealand, 1995.
 -top right- Dave Lee, Crystal Mountain, WA, 1996.
 -bottom left- Todd Schlosser, Dave Lee, and Jamie
 Lynn, Kirkwood, CA 1996.
 -bottom right- Todd Schlosser, New Zealand, 1995.

Page 58-Dave Lee, tailtap in the backcountry, 1995.

Page 59-Todd Schlosser, method, grasser, cranker, etc. Tahoe 1996.

Page 60-Barrett Christy, cliffdrop in the backcountry, 1997.

Page 61-Tara Dakides, Mammoth CA 1999.

Page 62-Marisa Stoller, Tahoe backcountry, 1996.

Page 63-Kids in Panama, 1999.

Page 64-Kris Aluffi, Santa Catalina, Panama, 1999.

Page 65-Painting of Jesus with tile table in the foreground, The Prado, Spain.
 -bottom right- Tom Gilles, Darren Cingel, and Jim Rippey, jumping
 to a powder transition, Sugarbowl CA.
 -top right- Dave Rogers, Tim Manning, and Arlie Carstens,
 Alhambra, Spain.

Page 66-Mt. Tallac sunset, Lake Tahoe.

Page 67-Jason Cockrum 1995.

Page 68-Tracy Latzen 1995.

Page 69-I.J. Valenzuela and Tracy Latzen, double powder slash, 1996.

Page 70-Full moon rising in Tahoe.

Page 71-Allen Clark, Tyax Heli, B.C. 1997.

Page 72-Devun Walsh, WY, 1997.

Page 73-JP Walker and BJ lienes, double rail Utah, 1997.
 -right- Church in southern Chile, 1995.

Page 74-Billy Summers, La Parva, Chile 1996.

Page 75 -top- Tim Manning.
 -bottom- Joni Makinen and Daniel Franck, camping in the Sierras.

Page 76-Joni Makinen with Mt. Jefferson in the background.

Page 77-Circe Wallace, North Cascade Heli WA.

Page 78-Kevin Jones and Marcus Egge hiking at dawn in Tahoe.

Page 79-Nate Cole, Tahoe backcountry 1995.

Page 80-Nate Cole, Las Lenas Argentina 1999.

Page 81 -top left- Johan Olofson with Chilean kids.
 -bottom left- Aaron Vincent, Squaw Valley.
 -right- Dale Rehberg and Russell Winfield.

Page 82 -left- Mike Beallo, Las Lenas, Argentina 1999.
 -top right- James Jackson and Brian Thien, lighting fireworks
 on HWY 395.
 -bottom- snowed in at Termas de Chillan, Chile- Benjamin,
 Sebastian, Doug Austin, Roan Rogers, Miguel, & Nate Cole.

Page 83-Gabe Crane, Alpine Meadows CA, 1998.

Page 84-Boozer Daly, Mt. Rose NV, 1996.

THROUGH THE RINGS PUBLICATIONS

CONTACT: RUBEN SANCHEZ-ph/fax(530)546-5968

Wayne Meyer -Art director, design, and basically did everything
but shoot the photos.
Israel James Valenzuela-Black & White prints and foreward.
Rod Pina - Incredible color scans!